"I've got drama,
can't be stolen…"

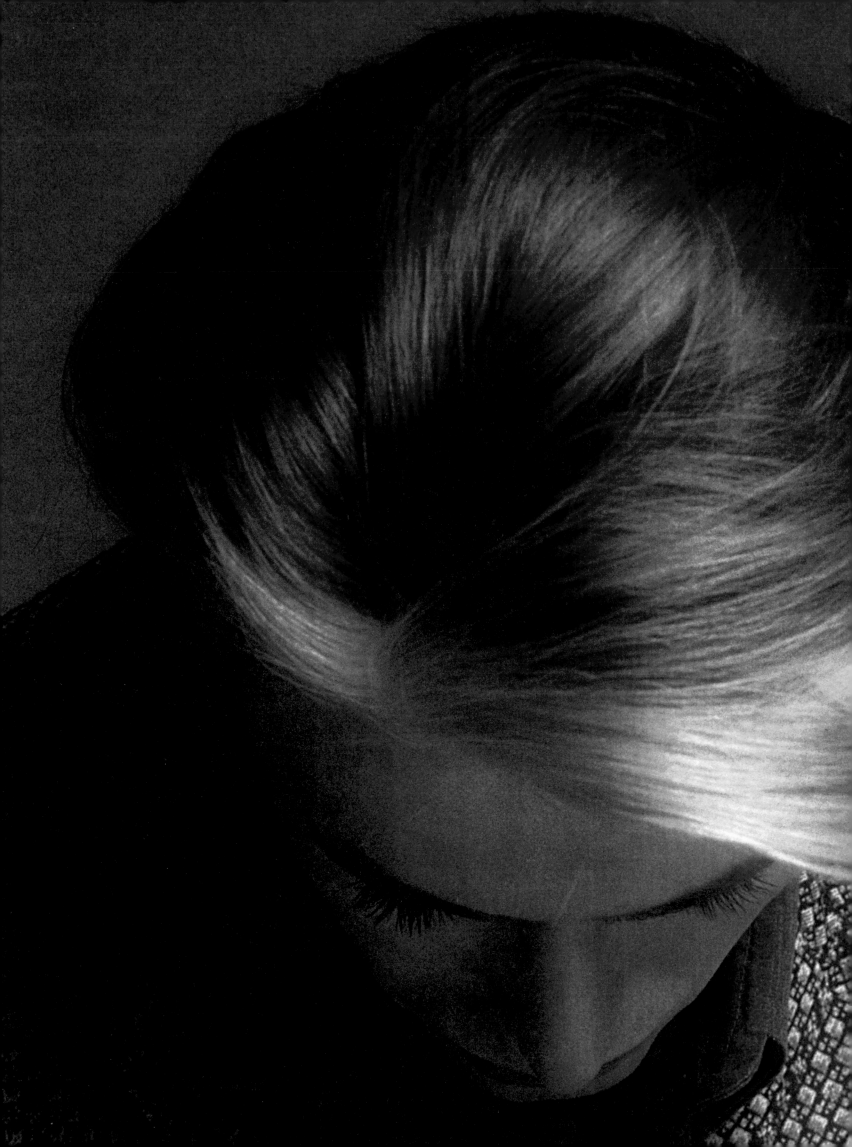

BOWIE

Photographs by
STEVE SCHAPIRO

pH **powerHouse Books** BROOKLYN, NY

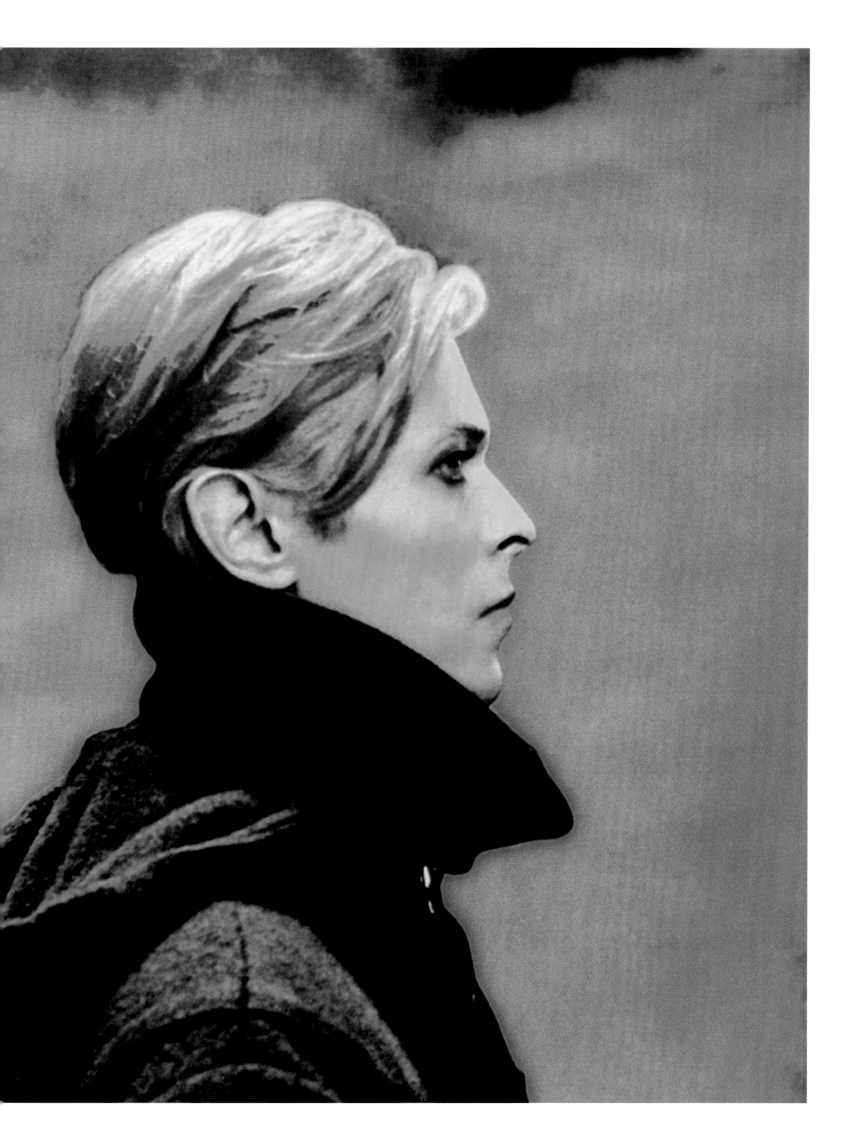

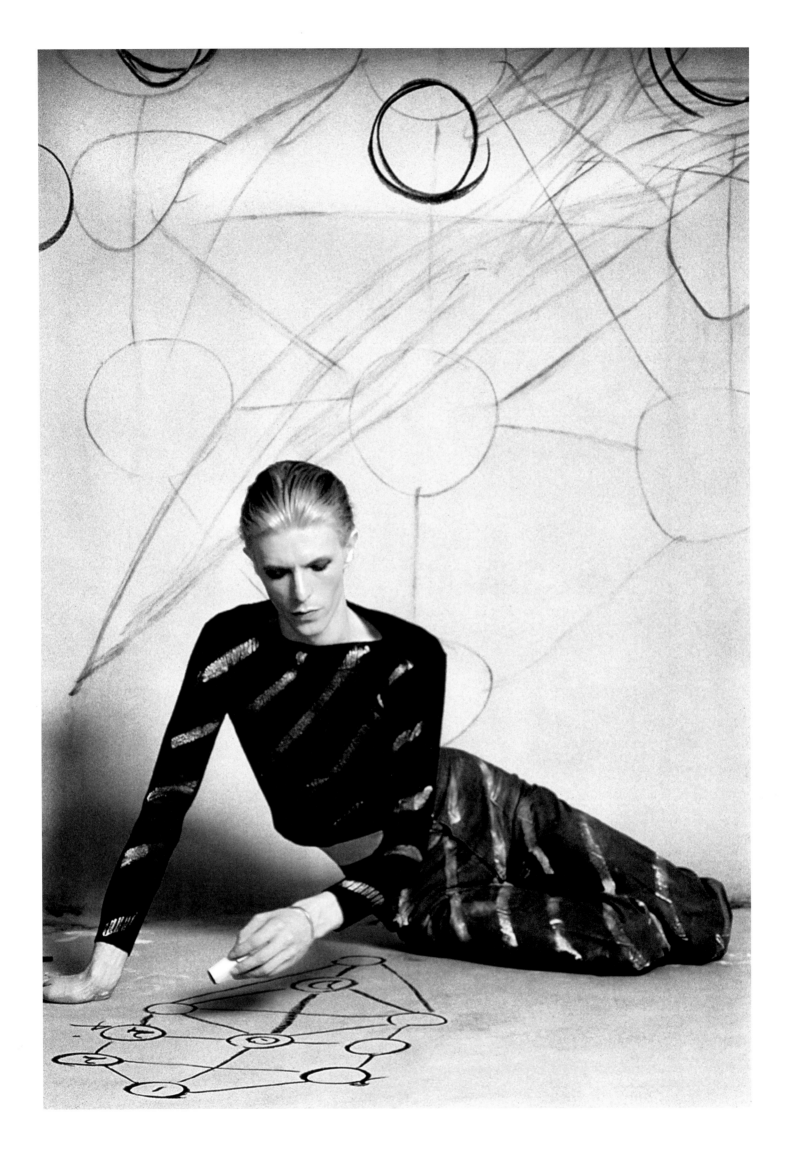

Kabbalah, Nuclear Fusion, and Immortality:
David Bowie's Signs
Albin Wantier

When he left this world, David left us the work of a lifetime—and some of the keys to help decipher an enigma he first unveiled some 40 years ago. Bowie was a work of art in his own right, and his passing might seem the final chapter. If you think so you are missing the signs.

2.

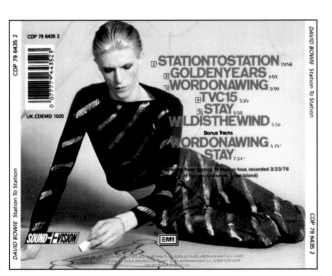

3.

It's no secret to anyone that I'm deeply shocked by the death of David Bowie, probably the performer I loved most of all for over 20 years. Since hearing of his death on Monday morning, I still can't believe it; Al Pacino's words in *Donnie Brasco* keep playing over and over in my head: "How can John Wayne die?"

That's how I feel about David Bowie.

Obviously, I'm not going to analyze all of Bowie's *oeuvre* piece by piece, or his constant obsession with eternity, immortality, and the concept of the superman. Whether in his songs, on his record sleeves, in his movie parts, and even in advertisements,[1] Bowie endlessly reiterated the idea of a superior entity that would survive him. Even in *Labyrinth,* despite his weird get-up and weirder soundtrack, Bowie steals a baby to ensure himself eternal life. *The Man Who Fell To Earth, Merry Christmas Mr. Lawrence,* and *The Hunger* all keep rehashing the themes of immortality and the superman.

What is immediately impressive about Bowie's death is the way the artist stages his own passing. Bowie always gave the impression of being master of his work's destiny, and his death was no exception. It was the last chapter in an all-encompassing masterpiece of which he was both scriptwriter and star. In the words of producer Tony Visconti:

"His death was no different from his life—a work of Art."

You don't need to be an expert in Bowie runology to realize that the "Lazarus" video is a farewell message. However, some of the details in *Blackstar* and "Lazarus" merit closer attention, insofar as they reveal an enigma subtly concealed by the artist.

The first striking feature is the costume worn by Bowie in the "Lazarus" video, appearing at about the two-minute mark. The black-and-white striped costume is the exact same one he was wearing in the photograph on the back of the CD version of *Station to Station*, his 1976 album—and in my view the best he ever made, heads and shoulders above all the others. The picture is taken from a series shot by the famous American photographer Steve Schapiro.

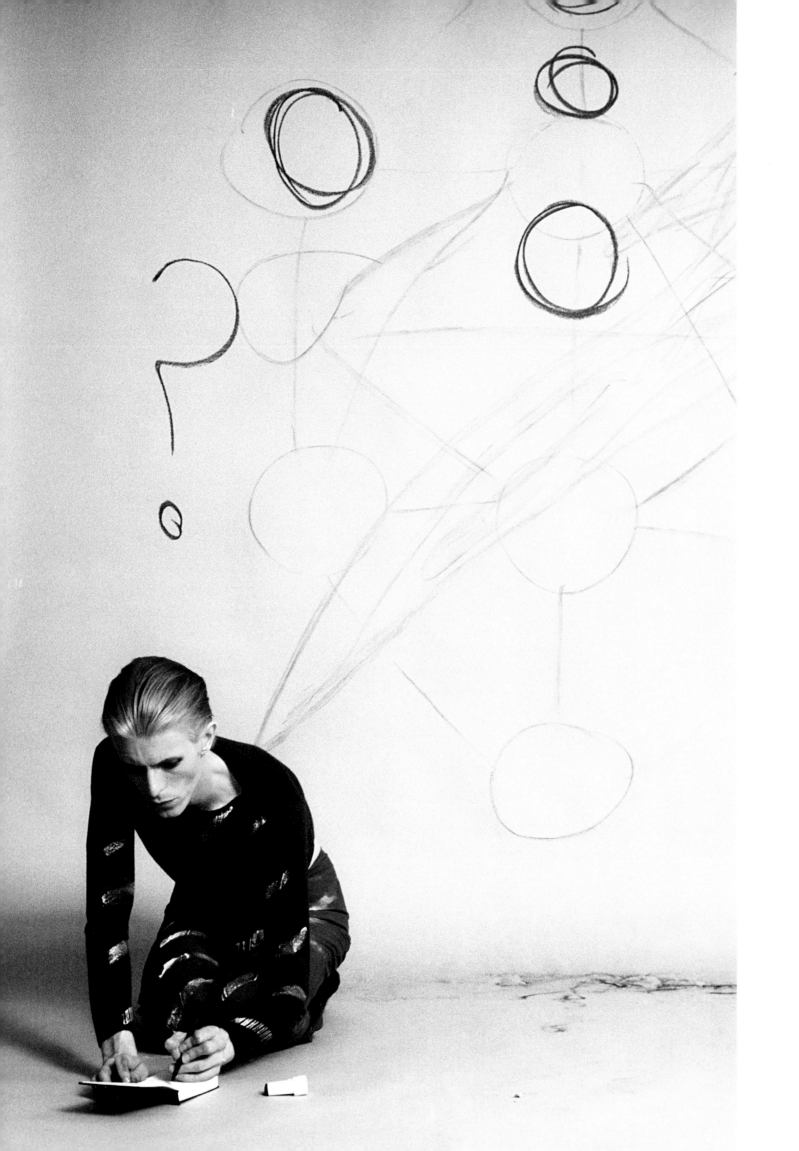

In David Bowie's work, there is no such thing as happenstance or coincidence—everything is carefully calculated.

In the 1974 photograph, Bowie is kneeling and drawing diagrams on the floor. Several reissues of the album show the same photograph with a wider frame, or even other pictures taken during the same session.

As outlined elsewhere online,[4] the diagrams drawn by Bowie in this photograph depict the Tree of Life, also known as the Tree of the Sephirot in Kabbalah. These Kabbalistic symbols also occur in the lyrics of title song "Station to Station":

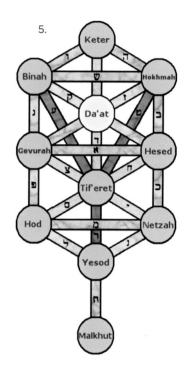

5.

Here are we
One magical movement
from Keter to Malkuth

Although I'm no expert on the Kabbalah, *Keter* (the Crown) and *Malkuth* (the Kingdom) are the first and last virtues on the Tree of Life.

Other pictures from this 1974 session show Bowie still tracing his diagrams, this time in a notebook, as he gazes thoughtfully into infinity. The widest-angle photograph shows an interrogation point on the wall. It can be deduced that Bowie is questioning the meaning of life. His doodles are a quest, a starting-point.

Back to 2016: Bowie dances around his deathbed in his 1976 costume, then sits at his desk, thinks, and then scribbles frantically in his notebook in a trance-like state, to the point of jumping off the margins of the page and onto the actual table. He appears to have found the meaning he has been searching for. The connection between both images, 40 years apart, is stunning. In "Lazarus," Bowie finishes his last chapter, stops taking notes and walks away, backwards. He has resolved his enigma, and the curtain can fall at last.

Although one cannot be absolutely categorical, a close-up of the writing in the book appears to show that it is a series of

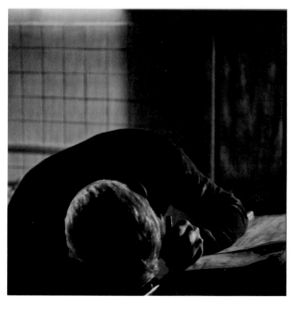

6.

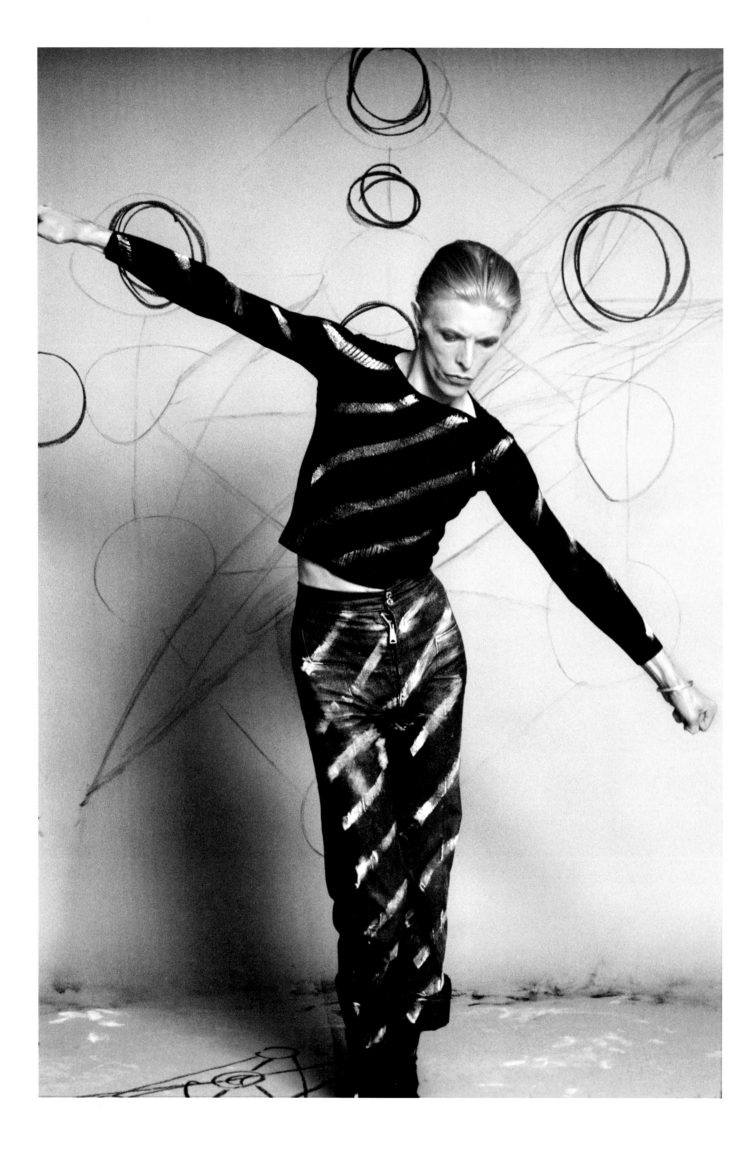

geometrical lines rather than a continuous text. Are they new Kabalistic symbols? Only Bowie can know for sure.

Another image, however, may supply the beginning of an answer. In the "Lazarus" video, Bowie has left a number of clues, which leads us back to a 1976 image as well as to the unusual diagrams...which uncannily remind the viewer of other symbols, this time in connection with *Blackstar*.

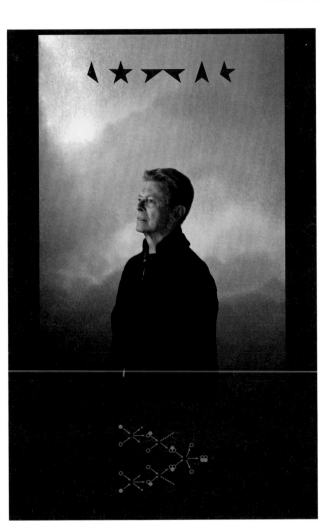

9.

When I ordered the vinyl version of *Blackstar*, I opted for the bundle version with three lithograph prints. One of them features a set of symbols eerily like those in the 1974 photographs.

After checking with a friend,[7] I learned that they were in fact chemical formulas. The drawings represent the various stages of the nuclear fusion, which leads to the formation of a sun.[8] Although I'm about as much of an expert about chemistry as I am about the Kabbalah, this is definitely a process in which atoms of hydrogen and helium are fused, releasing a colossal amount of energy that leads to the formation of a star.

I'm a blackstar...

This leads us back to the video of "Blackstar," the first release of the album, which beyond a doubt was Bowie's final testament and which he wrote fully knowing what he was doing.

Symbols abound in the "Blackstar" video. There be no doubt as to the identity of the dead astronaut shown as the beginning of the video: Major Tom from "Space Oddity," once lost in space, and who now at last has been found. In the video, Major Tom undergoes the funerary rites that form the main theme of the video as a whole.

So, how to interpret this tangle of symbols?

In the "Lazarus" video, Bowie resolves the enigma of life, which he had been endeavoring to do since 1976. His life, which was indistinguishable from his work, led him to enact various characters of his own devising; his life was in itself a work of art. Now that he has finished, Bowie can close the book. However, the last chapter does not end with the artist's passing—that would be too simple. David Bowie is not the kind to just disappear just like that from our world. The chemical symbols that accompany the *Blackstar* release point where he's going: an artistic nuclear fusion of two elements that creates enough energy to make a sun.

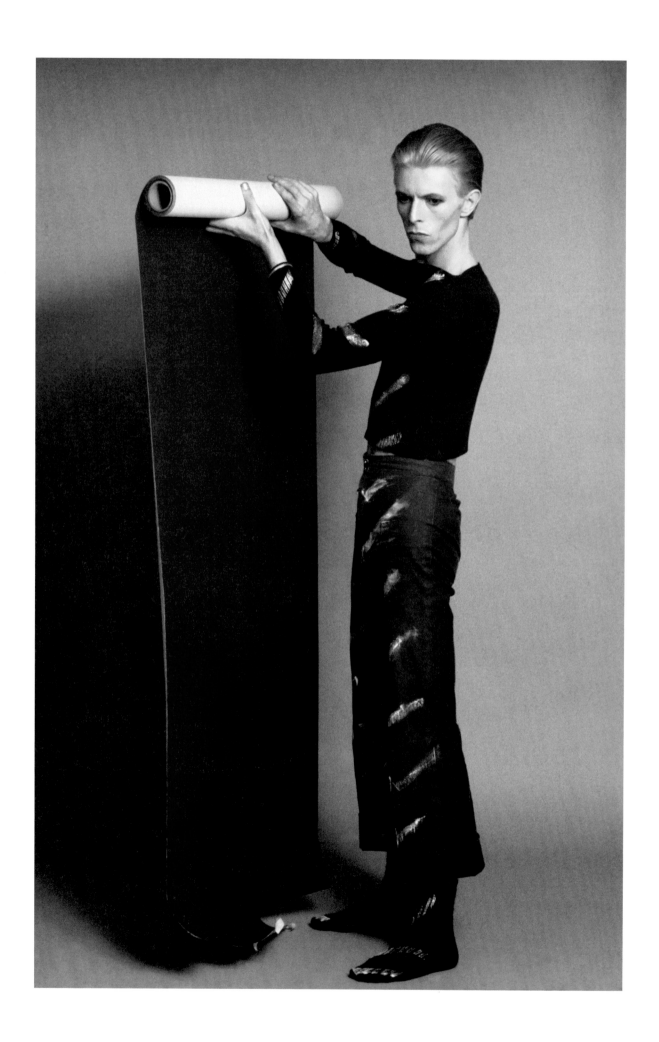

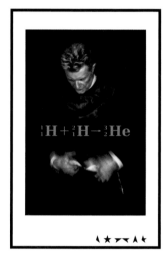

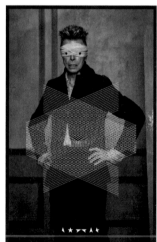

11.

In the "Blackstar" video, both nuclei necessary for fusing are present: Major Tom, the embodiement of all of Bowie's alter egos (Major Tom, Ziggy Stardust, Aladdin Sane, Halloween Jack, Thin White Duke, Nathan Adler) and David Bowie the man—the character and his creator, at last fused. Together, they generate enough energy to create a sun, a source of eternal light. *I'm a blackstar.* Bowie is at once absorbed by his creation, and his life's work, his characters and personae, have fully absorbed him. He has reached nirvana: his life—his work—is immortal. His life and work now being one and the same, David Bowie is now eternal.

The merging of the actor and creator completes the circle. *From Keter to Malkuth*, Bowie has now entered the Kingdom, the plan for which he doodled some 40 years before on a photo shoot for an album:

The tenth sephirah is Resplendent Intelligence. It is the receptacle of all influences. Malkuth embodies the ultimate stage of form, dense and palpable, which cannot exist in a more concrete form. It is our universe, our planet, our body, and all things animate and inanimate that surrounsd us. Malkuth is the Kingdom of imagined forms that are at last realized. Malkuth is also the place where the links between force and form deteriorate and break, the threshold where one "gives up one's soul," where what cannot be assimilated turns to waste. The challenge to man is to one day be able to master the myriad energies and influences swarming in his kingdom.[10]

I always knew that Bowie was a god. Now I have proof. At last I can begin to mourn him.

Albin Wantier is a musician and freelance journalist based in Belgium; since his teenage years, Wantier has been fascinated by David Bowie's work, and after the artist's death published a version of this essay on his blog, describing how the "Lazarus" video refers to a series of pictures shot by Steve Schapiro in 1974. The original posting can be found at http://newkicksontheblog.blogspot.be

1 https://www.youtube.com/watch?v=KHOFkOW1iB0 Bowie's advert for Vittel
2 Photo by Jimmy King, used with permission of the David Bowie Archive.
3 Station to Station CD packaging, 1991. © RCA.
4 http://www.centrosangiorgio.com/rock_satanico/simboli_esoterici/pagine_simboli_esoterici/bowie_e_la_cabala.htm
5 https://en.wikipedia.org/wiki/File:Ktreewnames.png
6 Video stills from "Lazarus." Dir. Johan Renck, 2016. © Sony Music Group.
7 Thanks Bruno!
8 https://en.wikipedia.org/wiki/Nuclear_fusion
9, 11 Lithographs included with *Blackstar* Special Edition. Photography by Jimmy King.
10 http://www.kabbale.org/arbre_sephiroth.htm [translated from the French by the author]

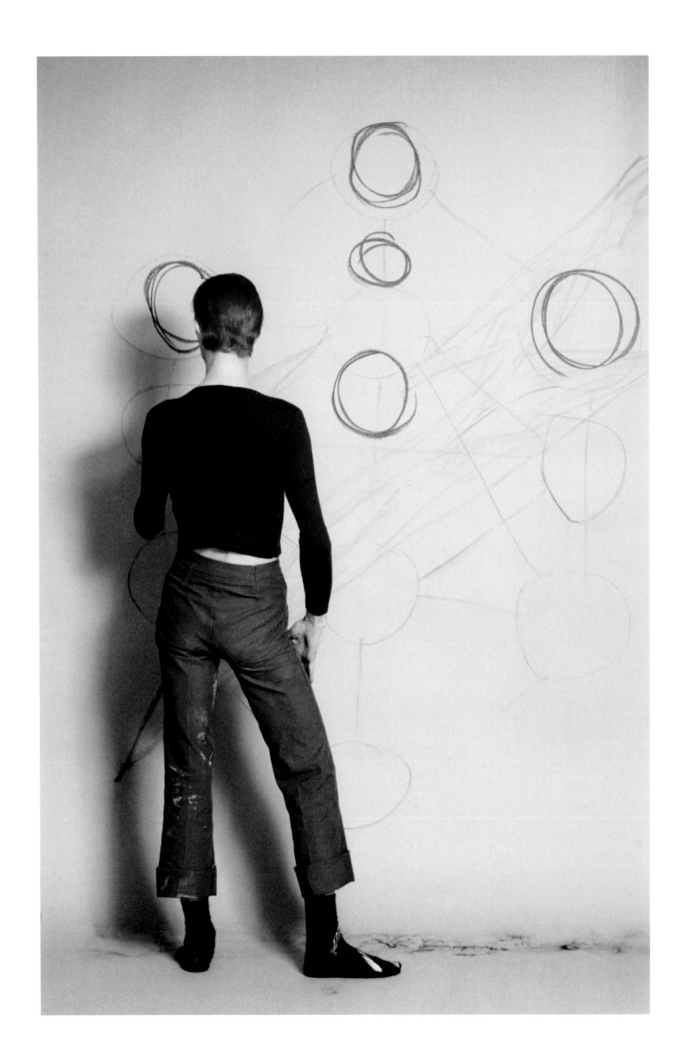

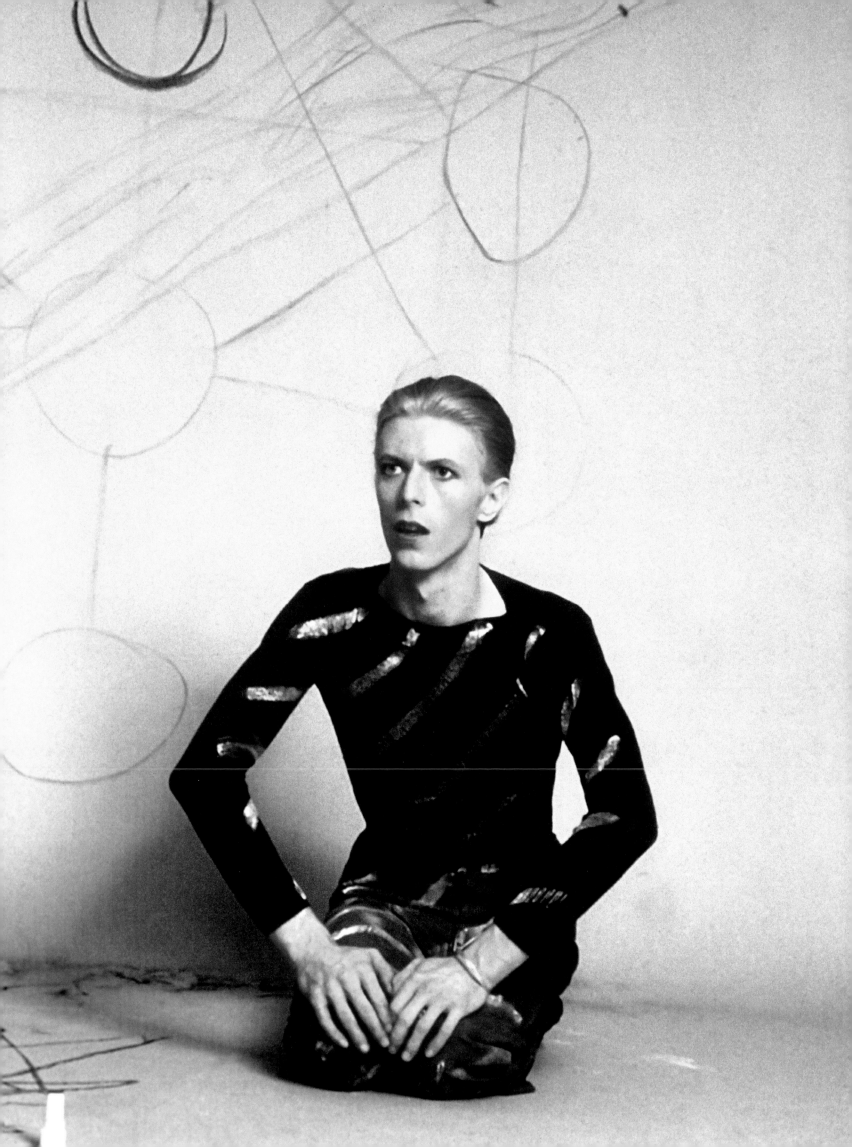

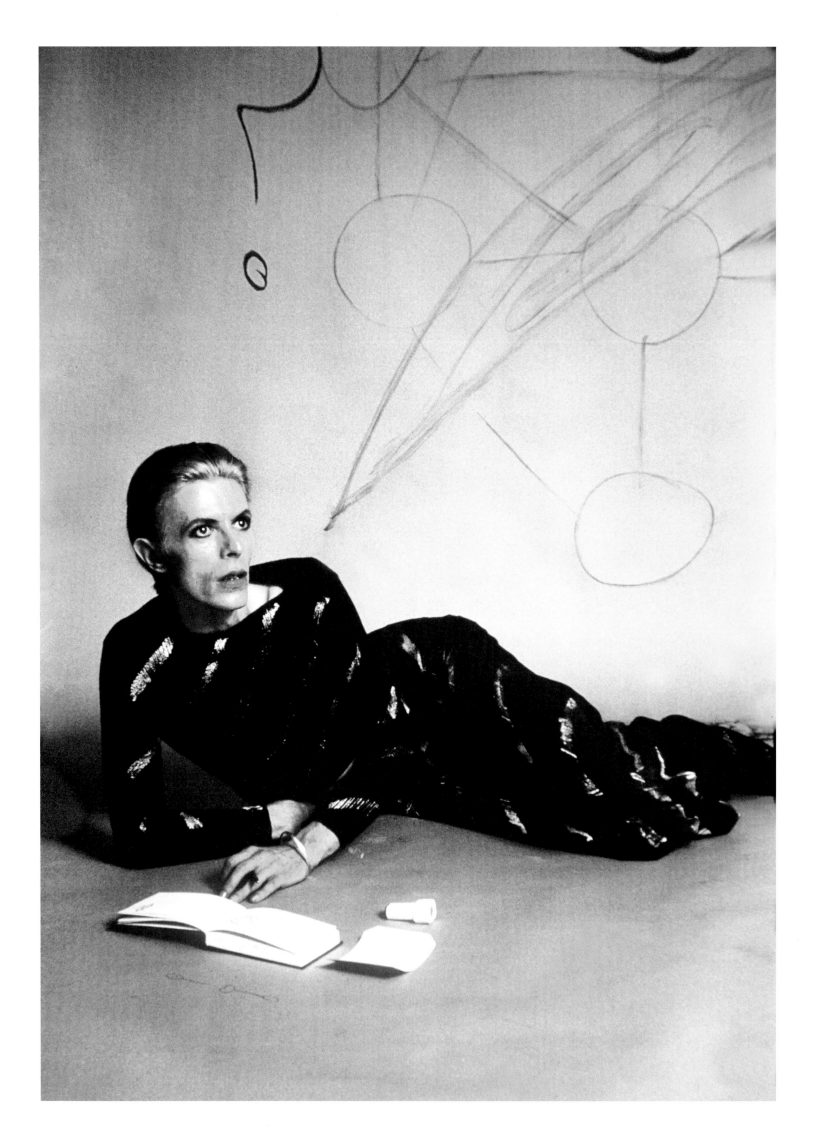

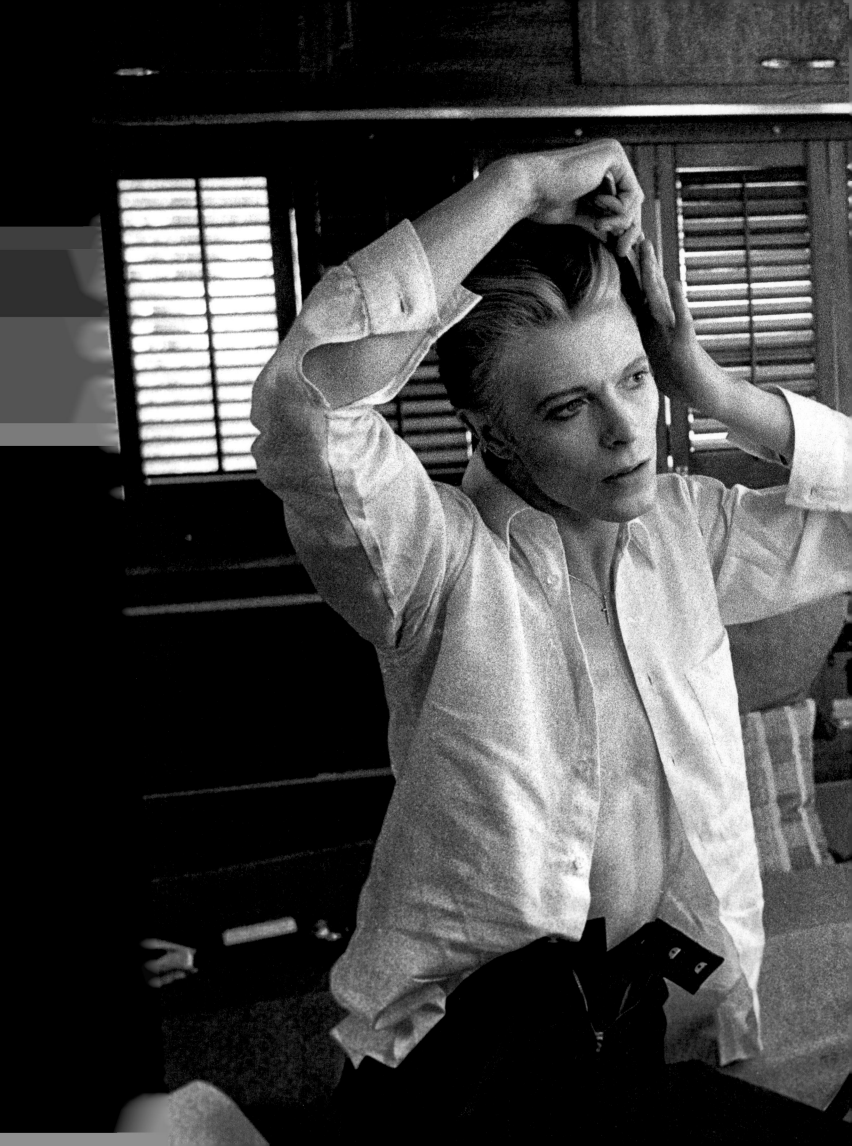

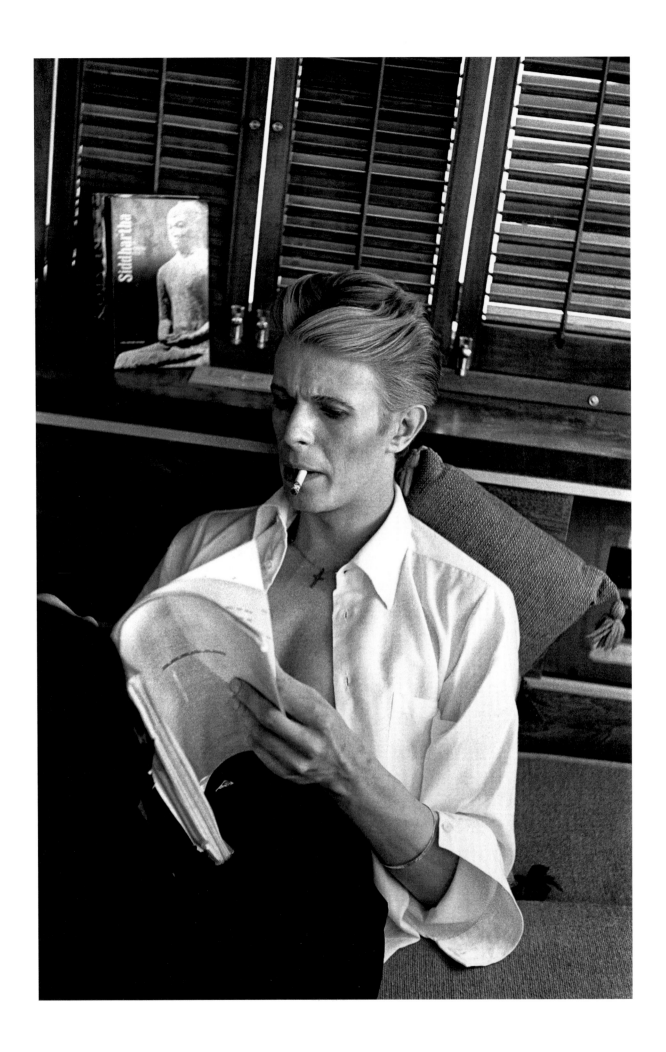

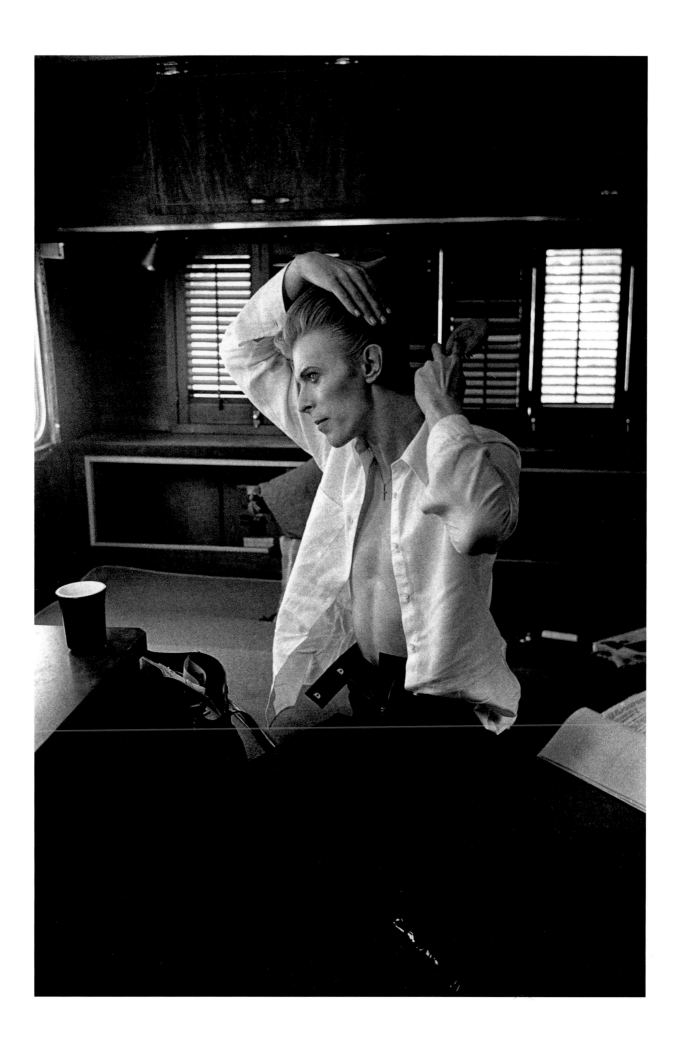

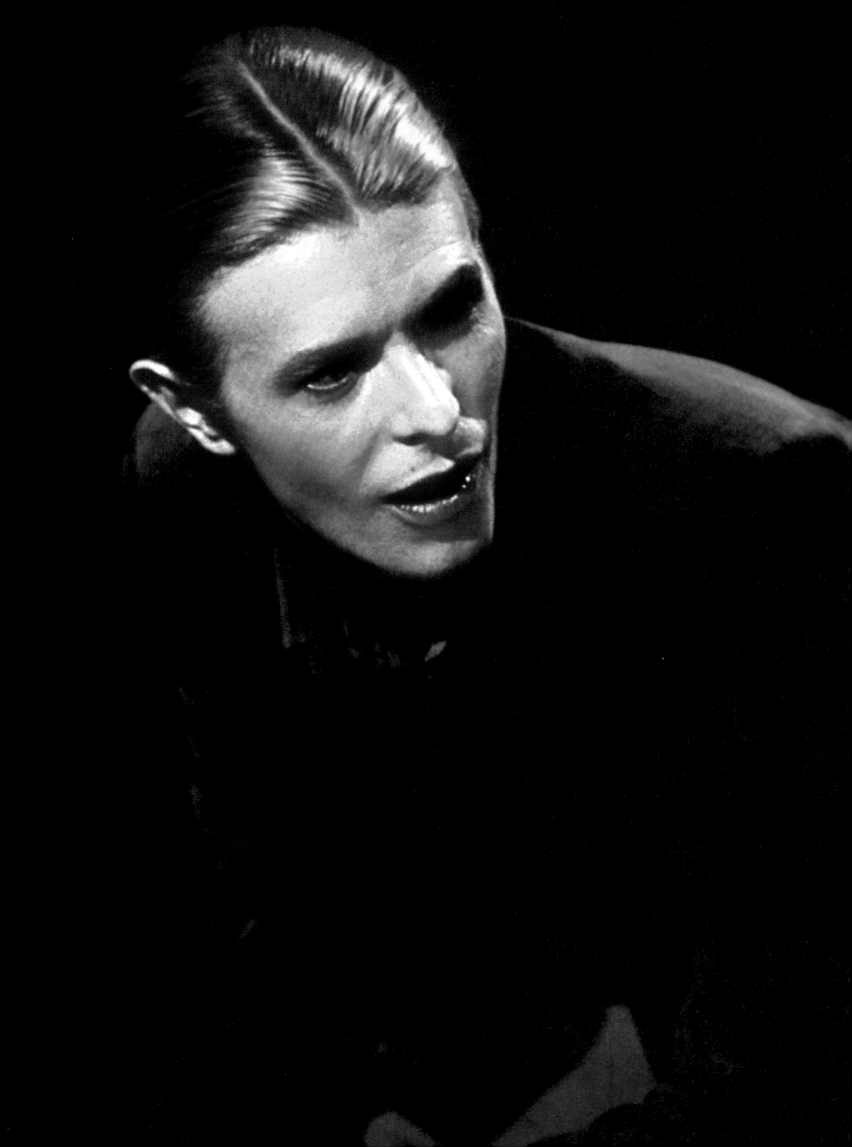

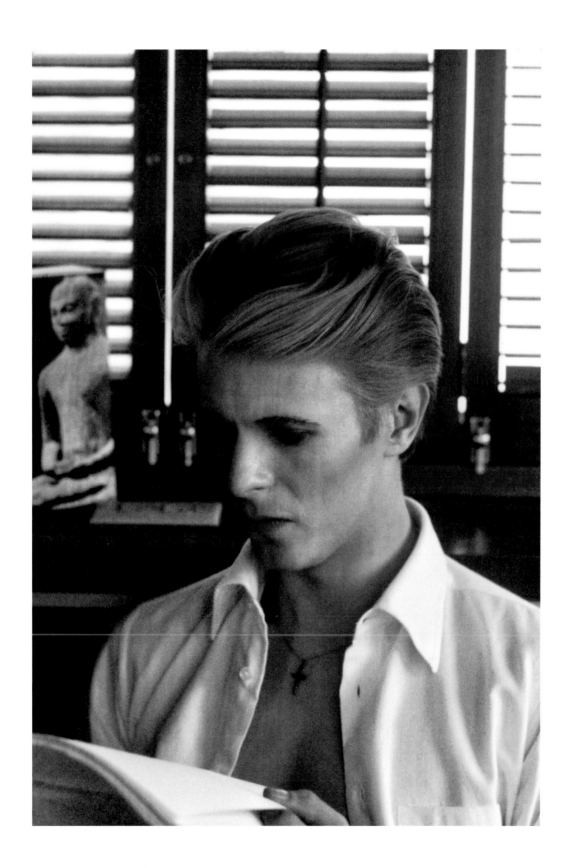

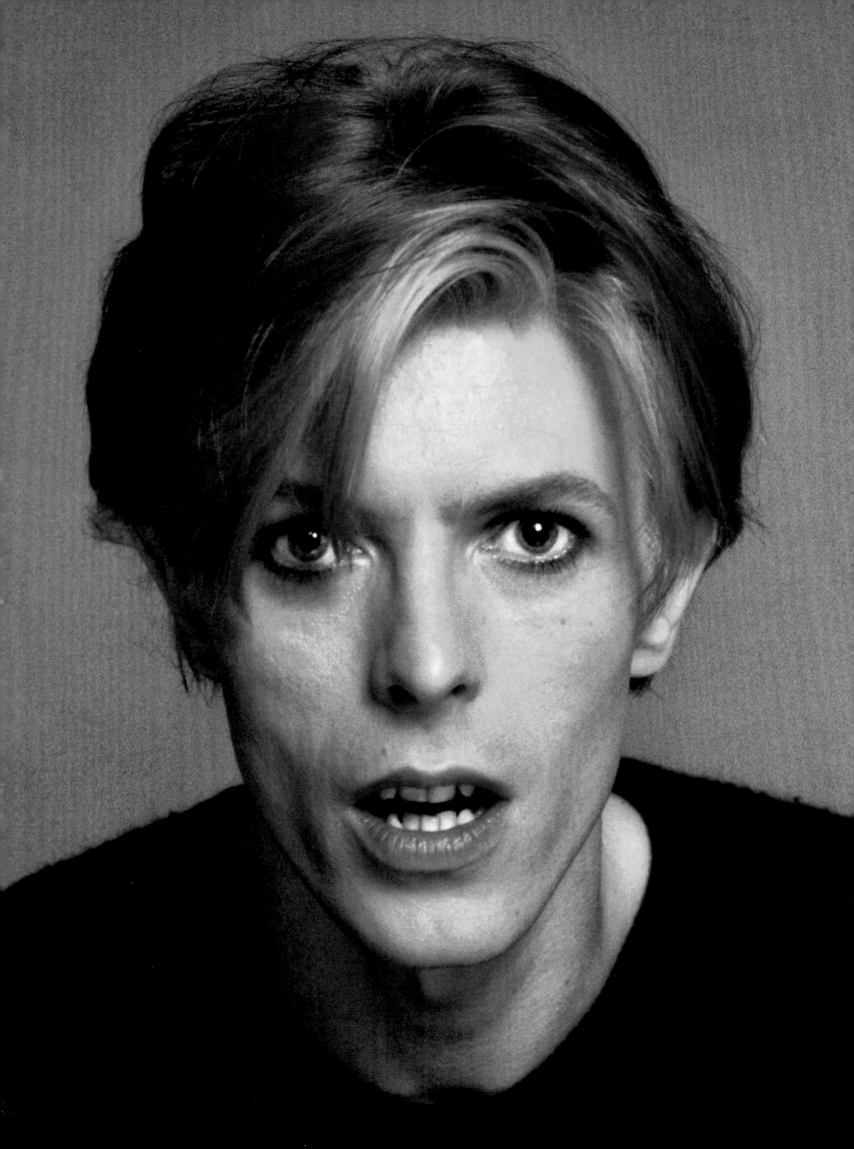

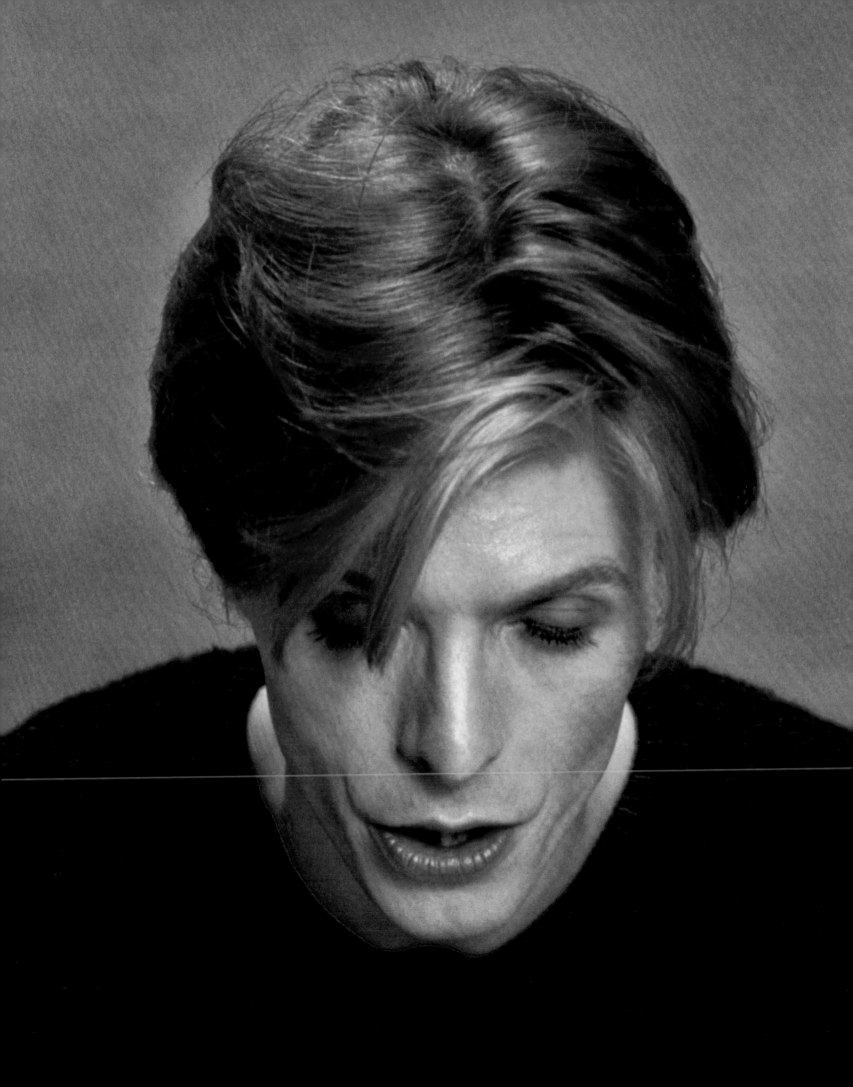

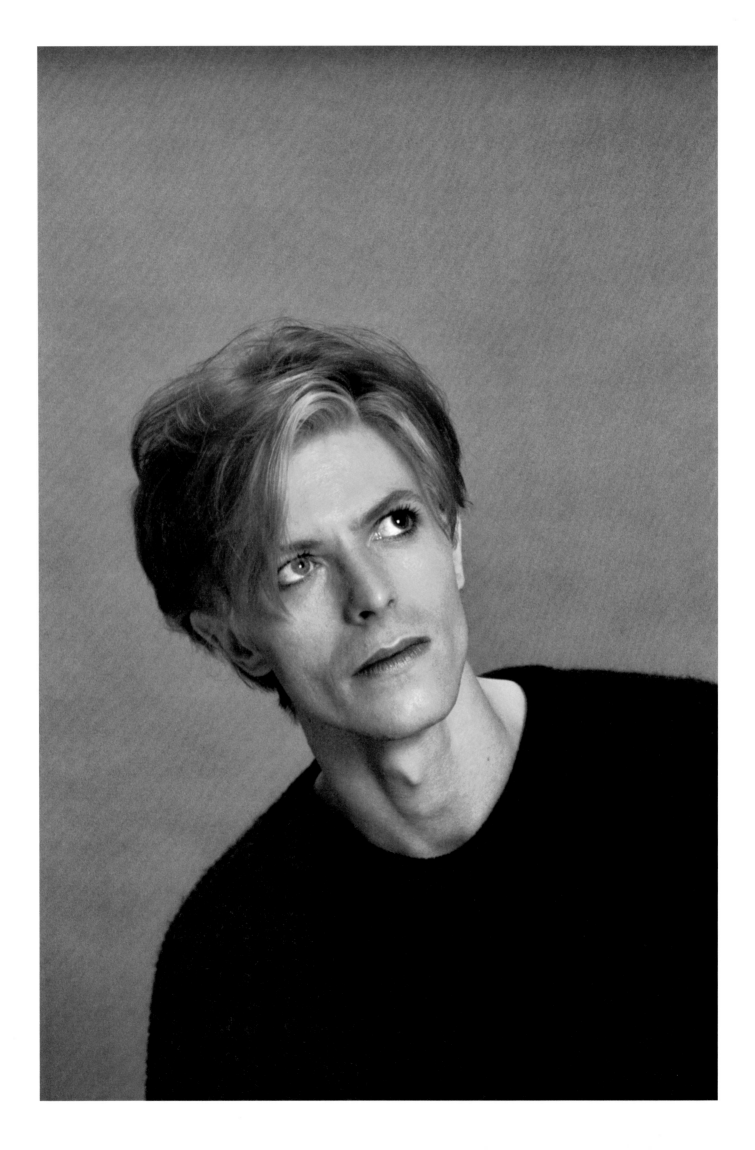

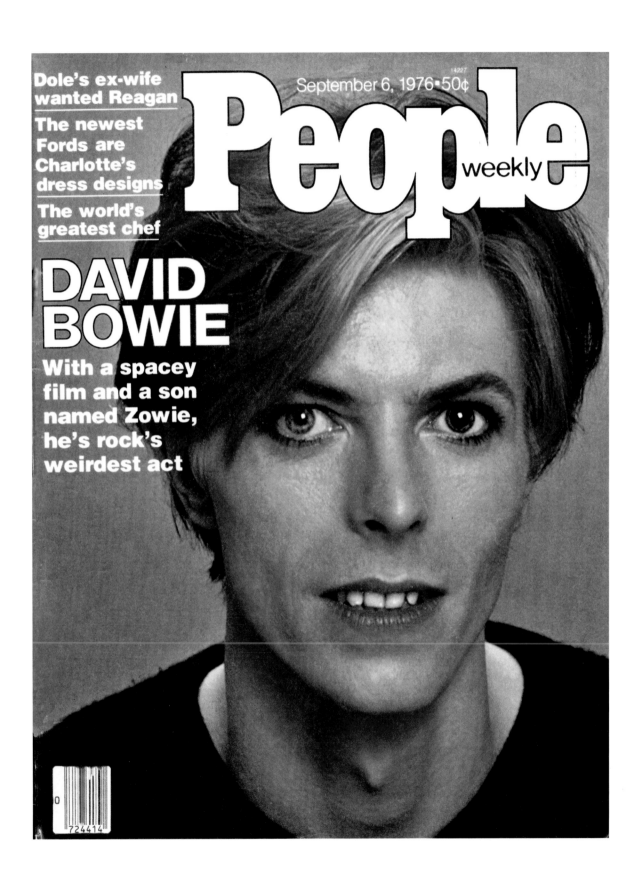

Dole's ex-wife
wanted Reagan

The newest
Fords are
Charlotte's
dress designs

The world's
greatest chef

September 6, 1976•50¢

People weekly

DAVID BOWIE

**With a spacey
film and a son
named Zowie,
he's rock's
weirdest act**

724414

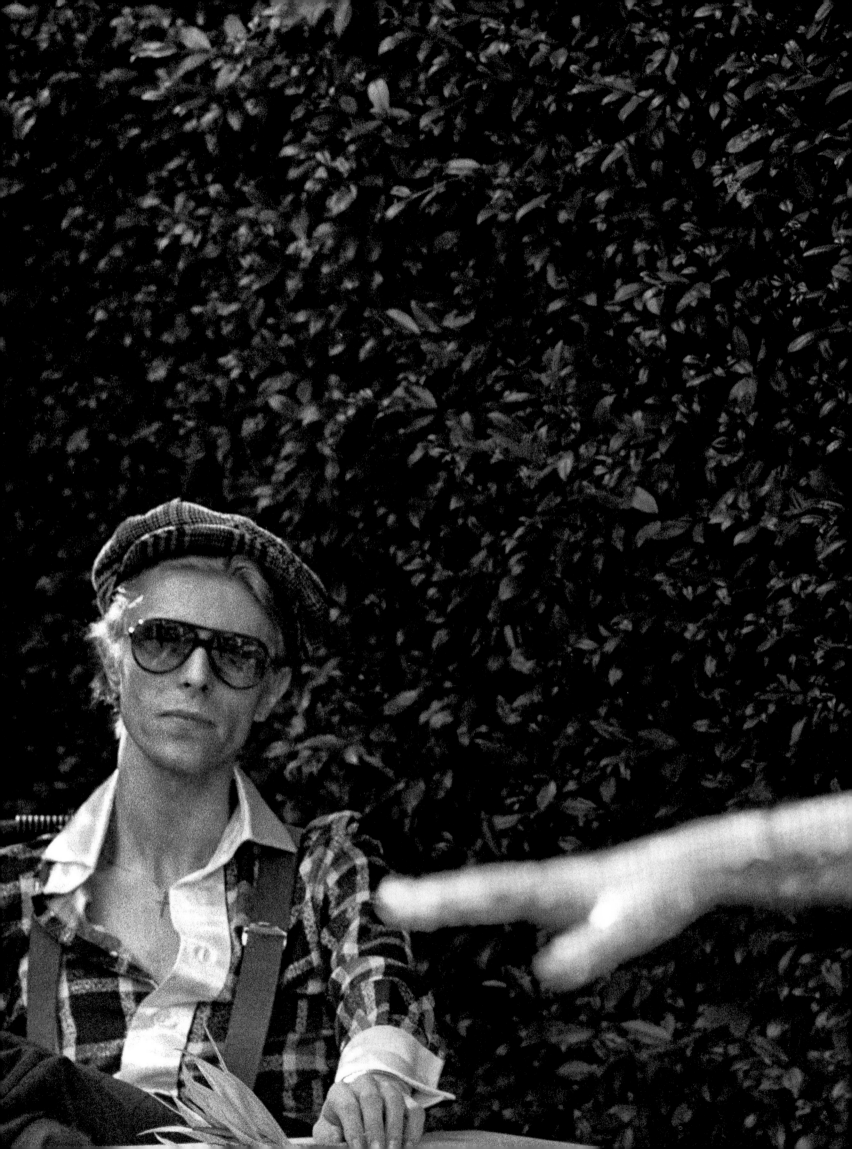

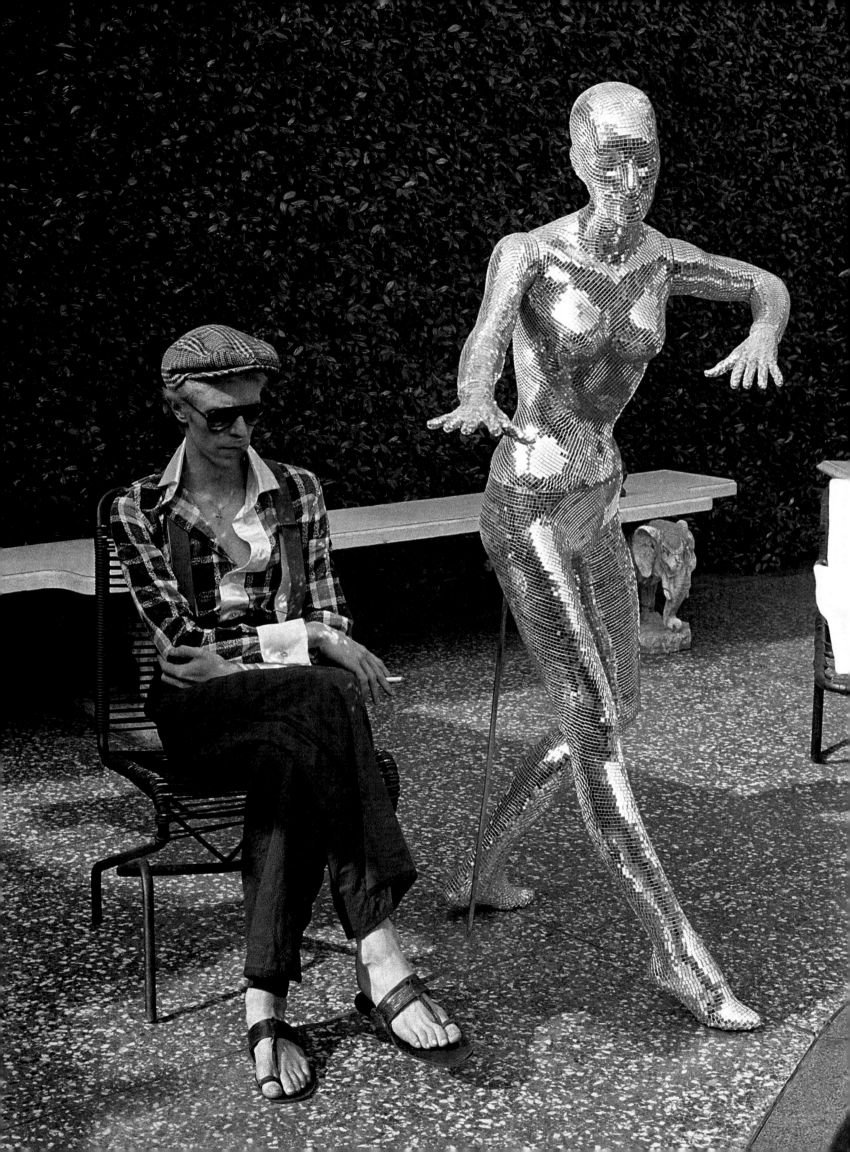

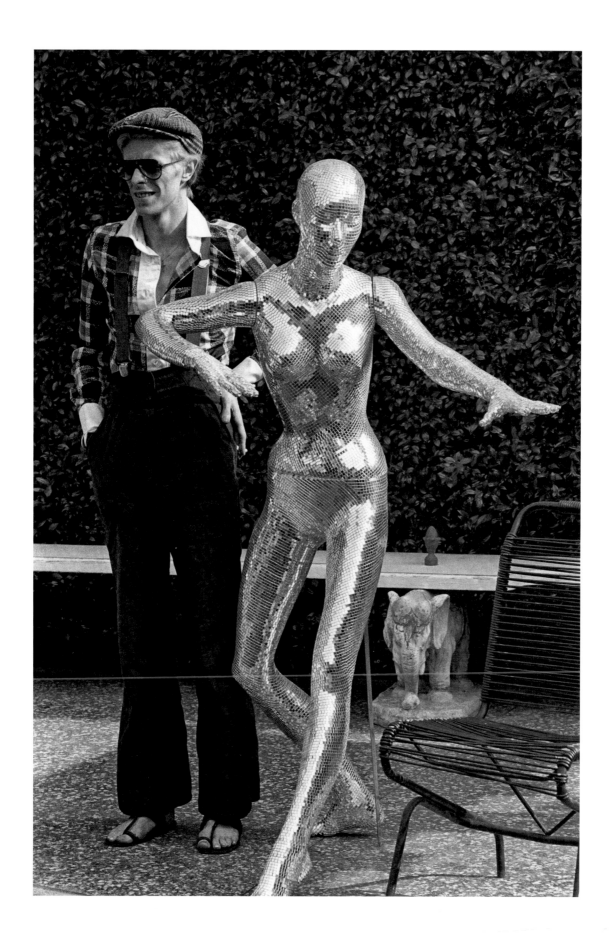

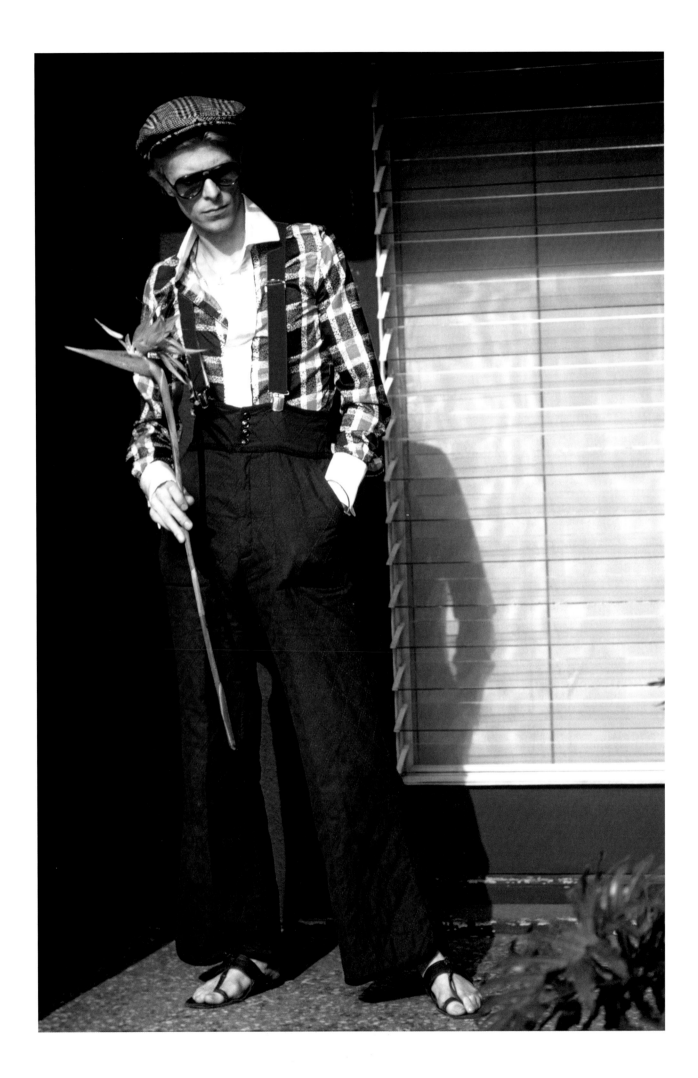

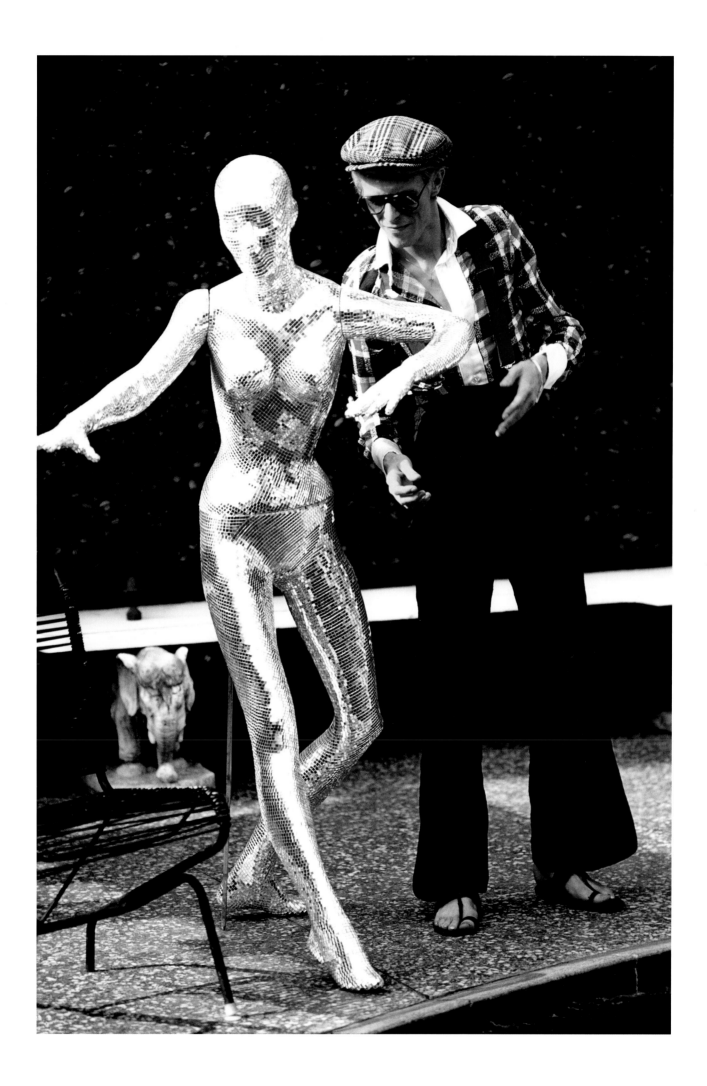

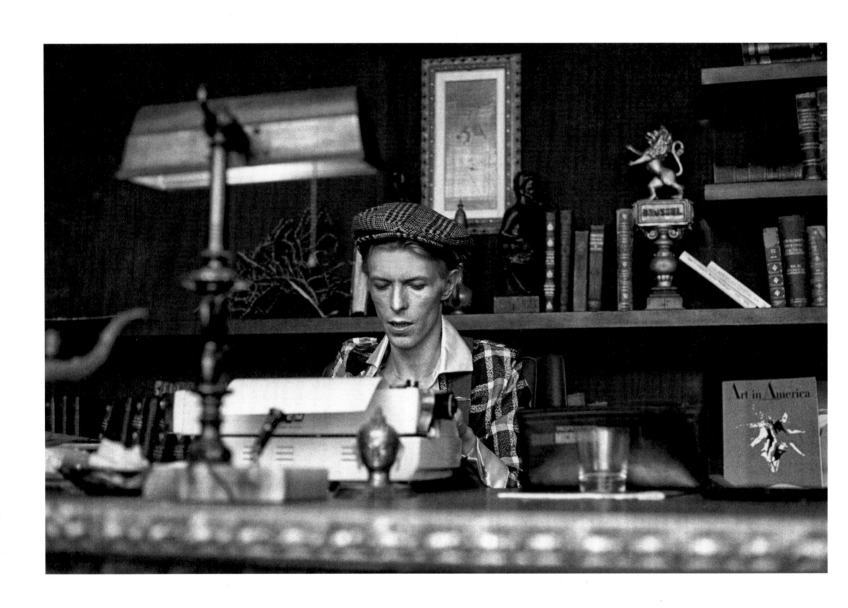

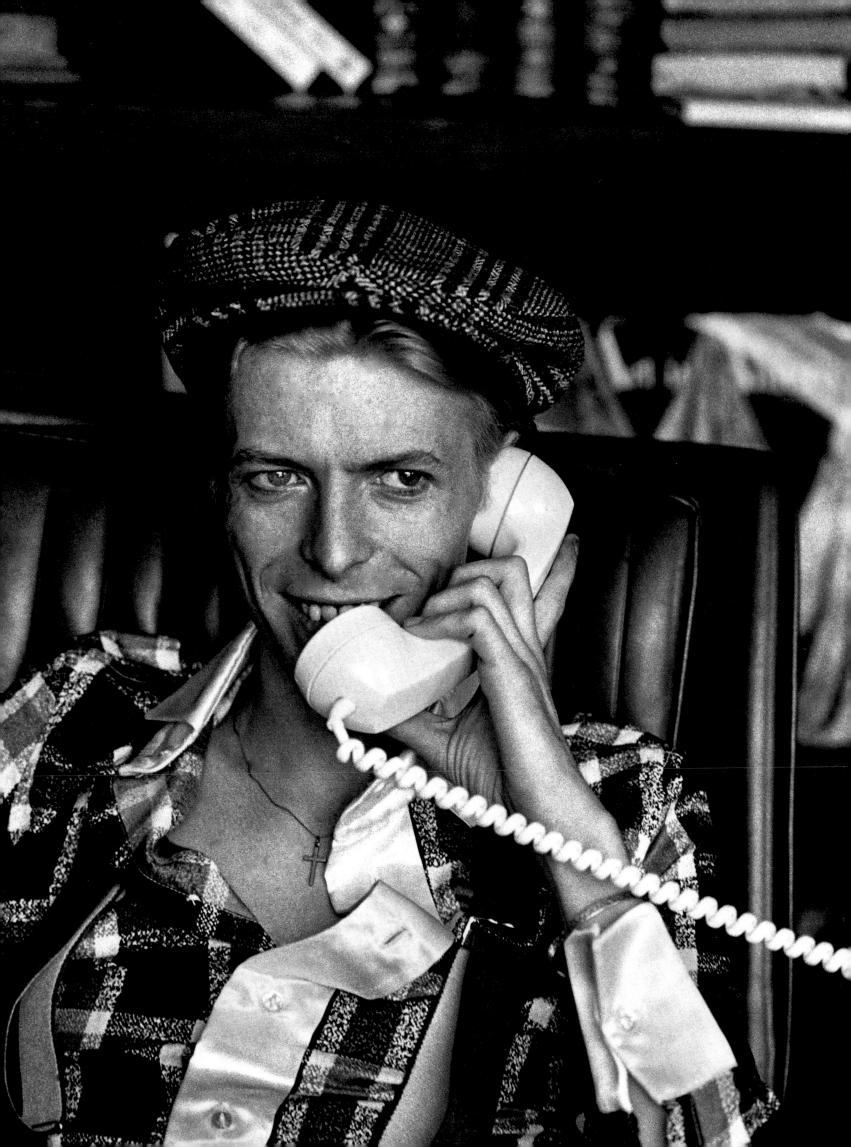

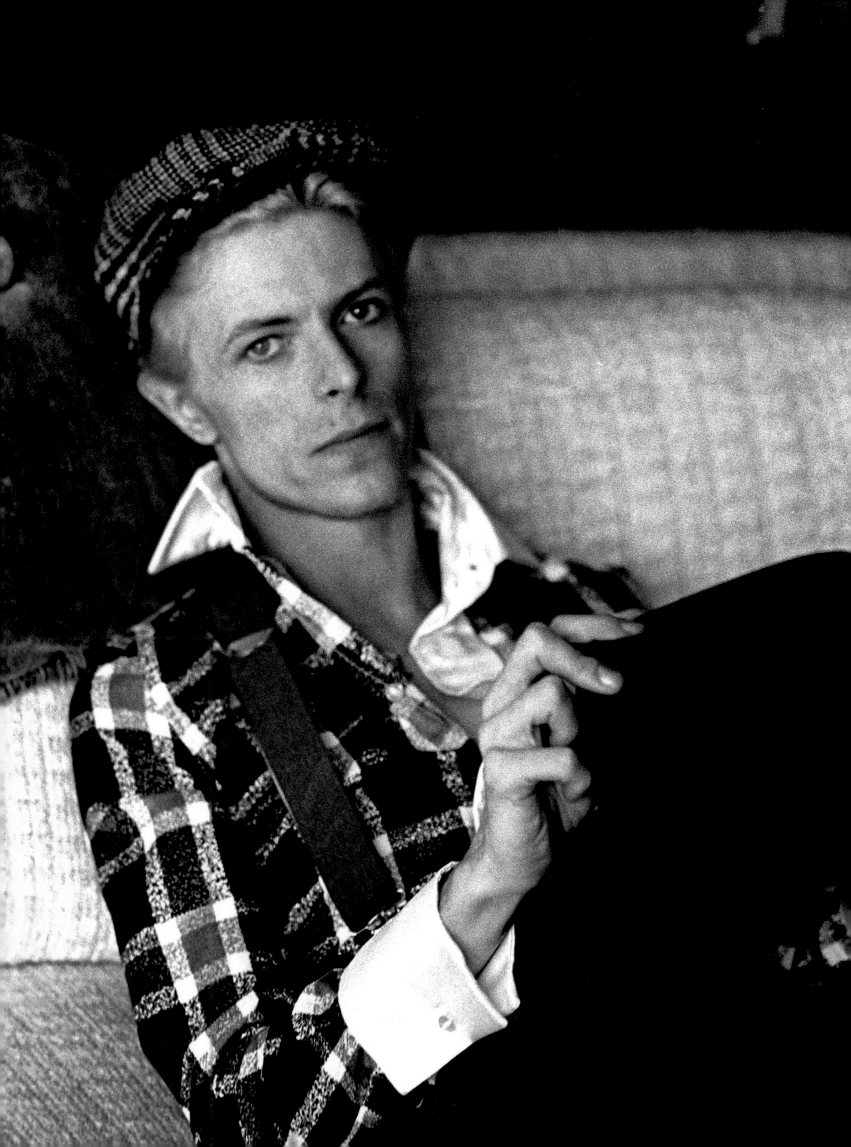

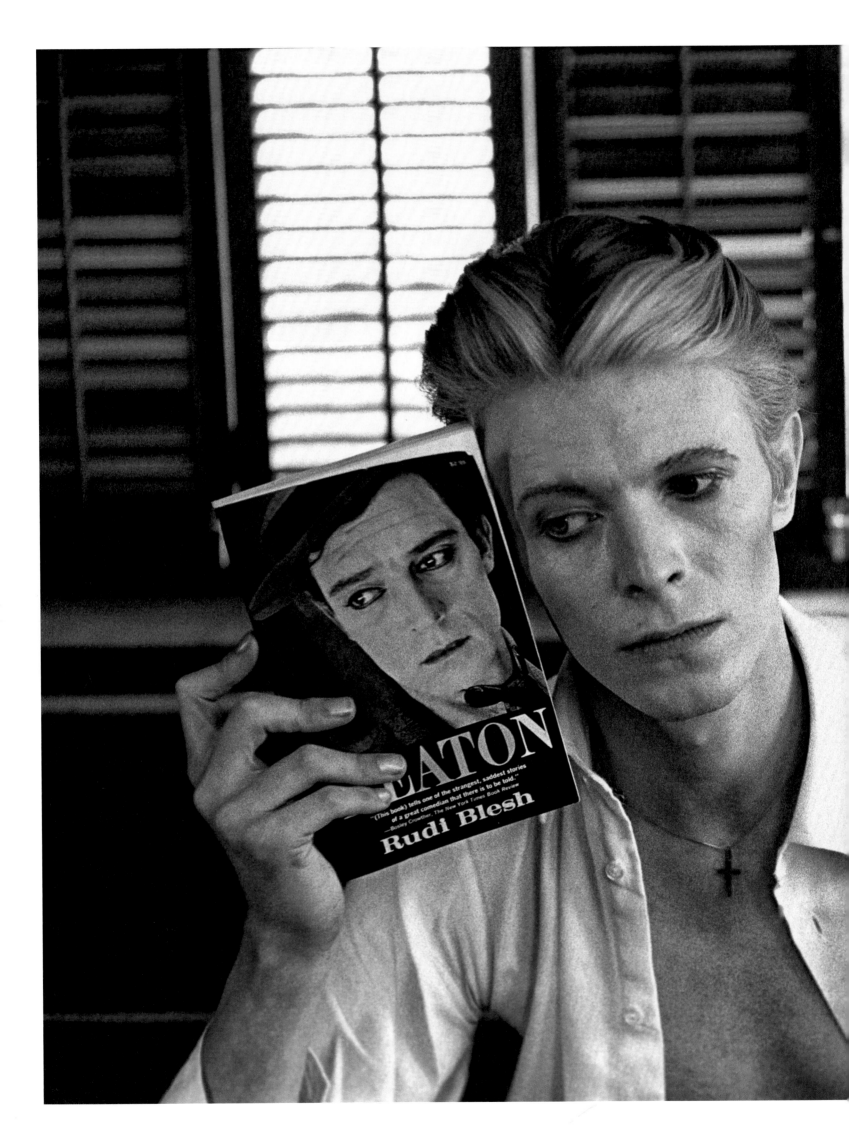

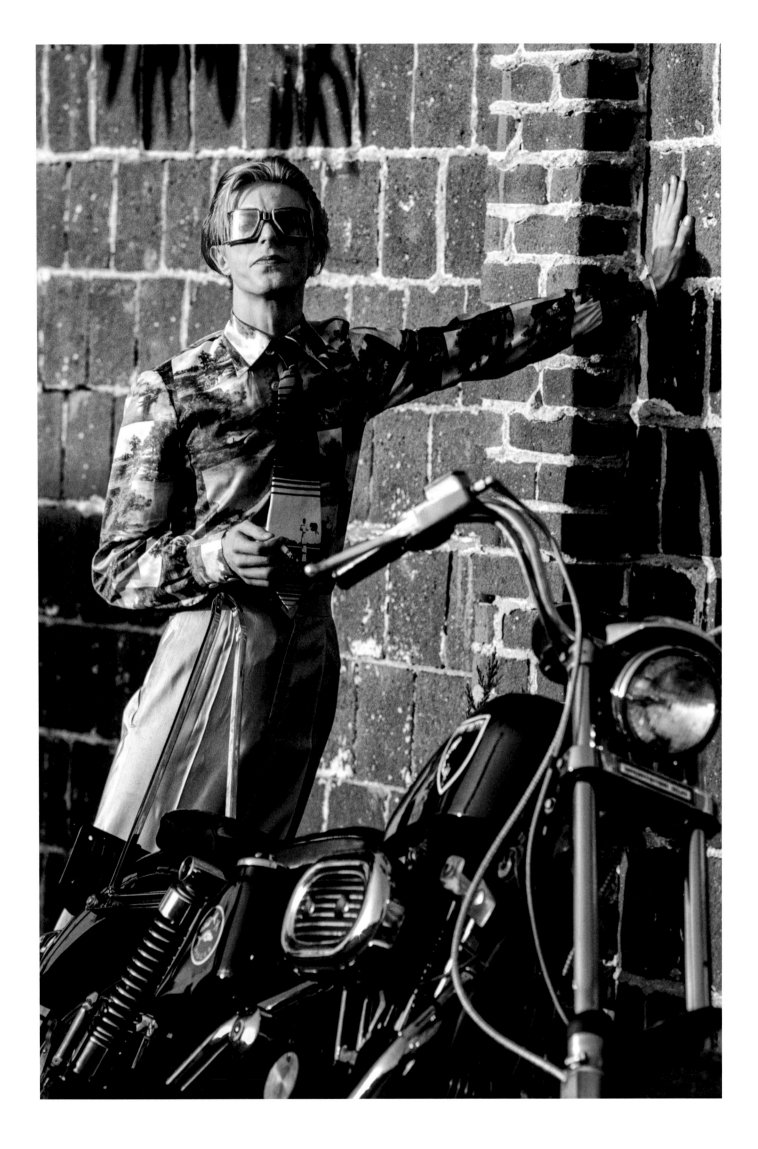

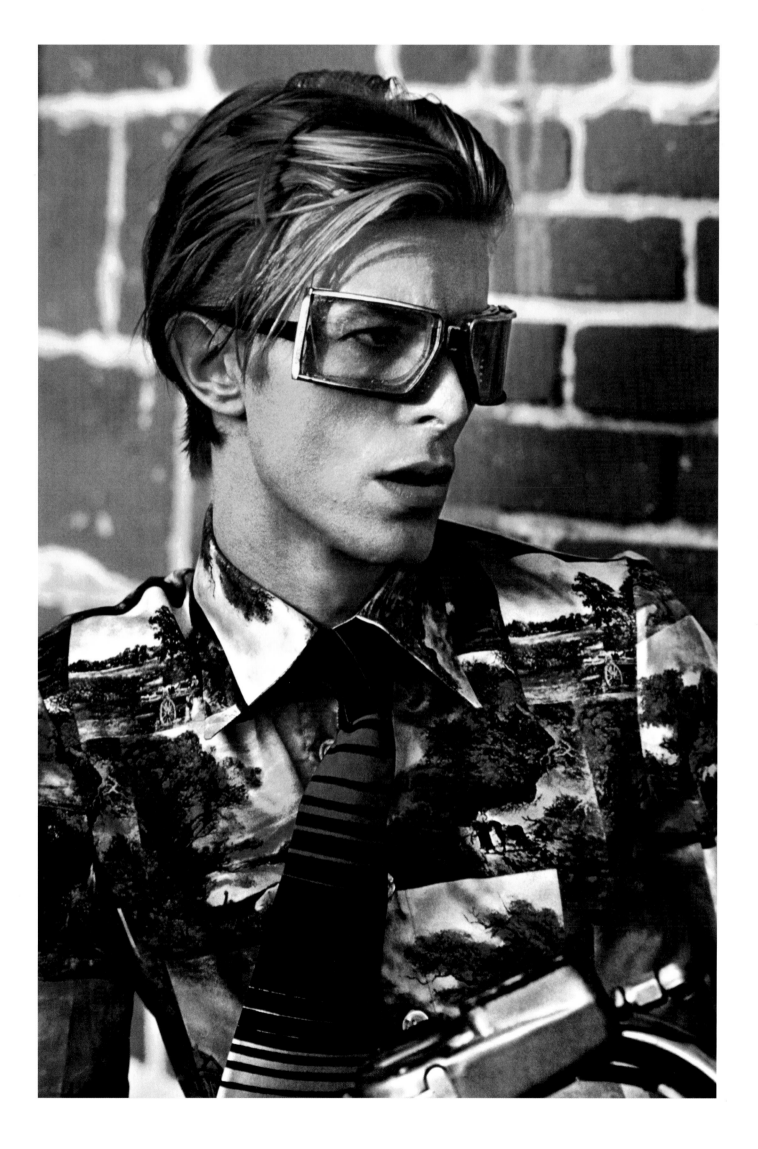

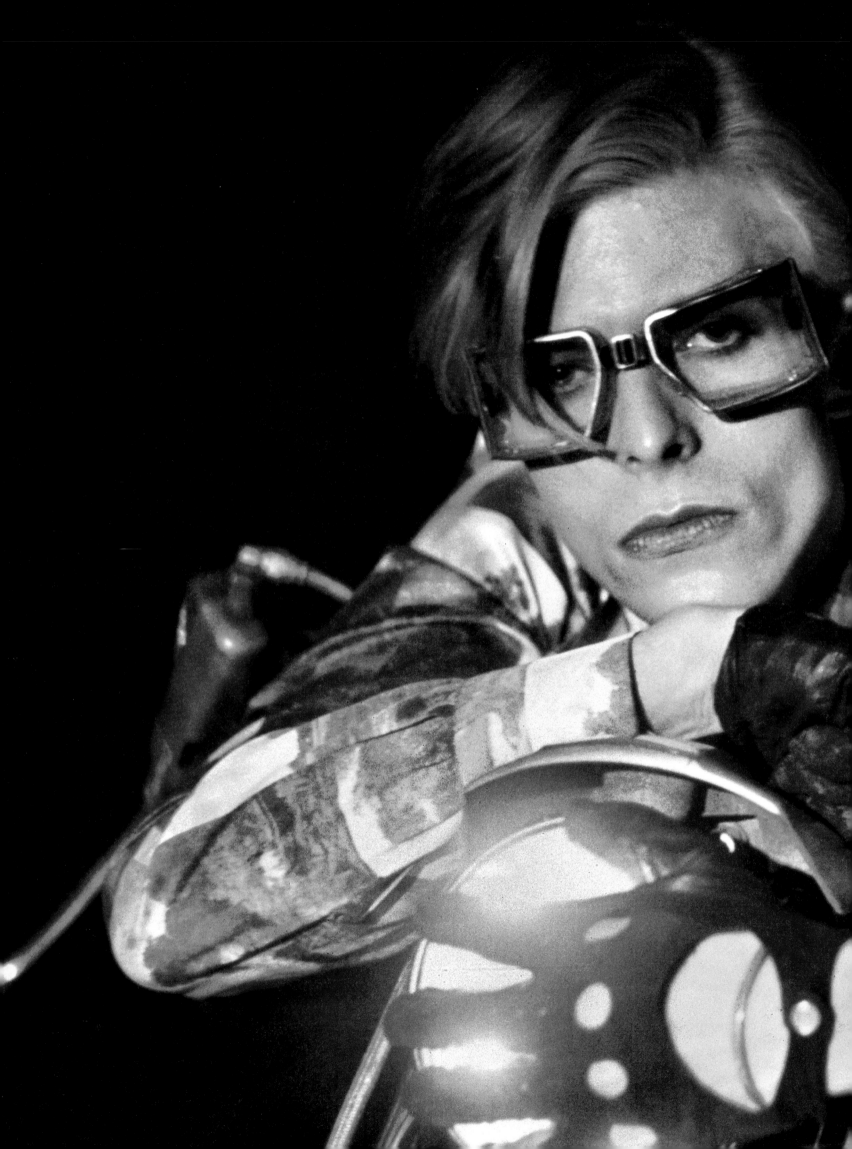

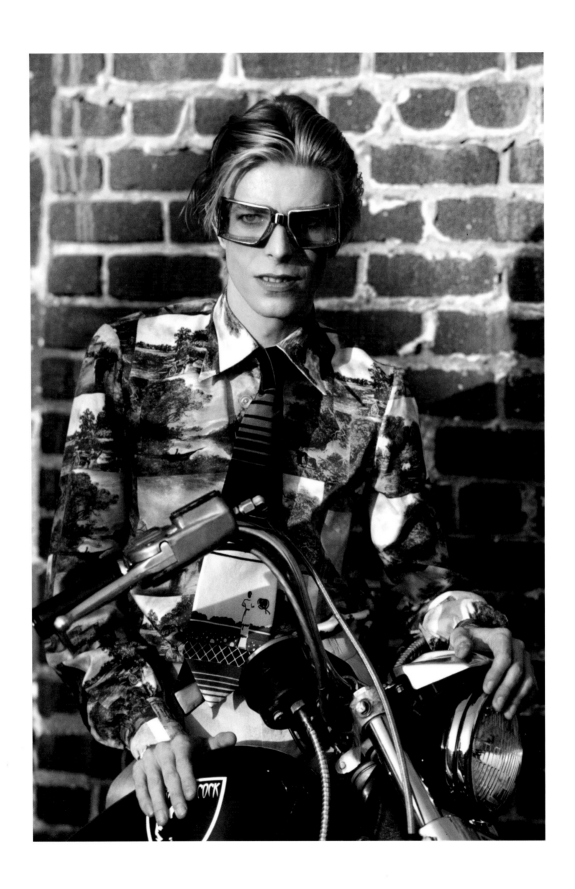

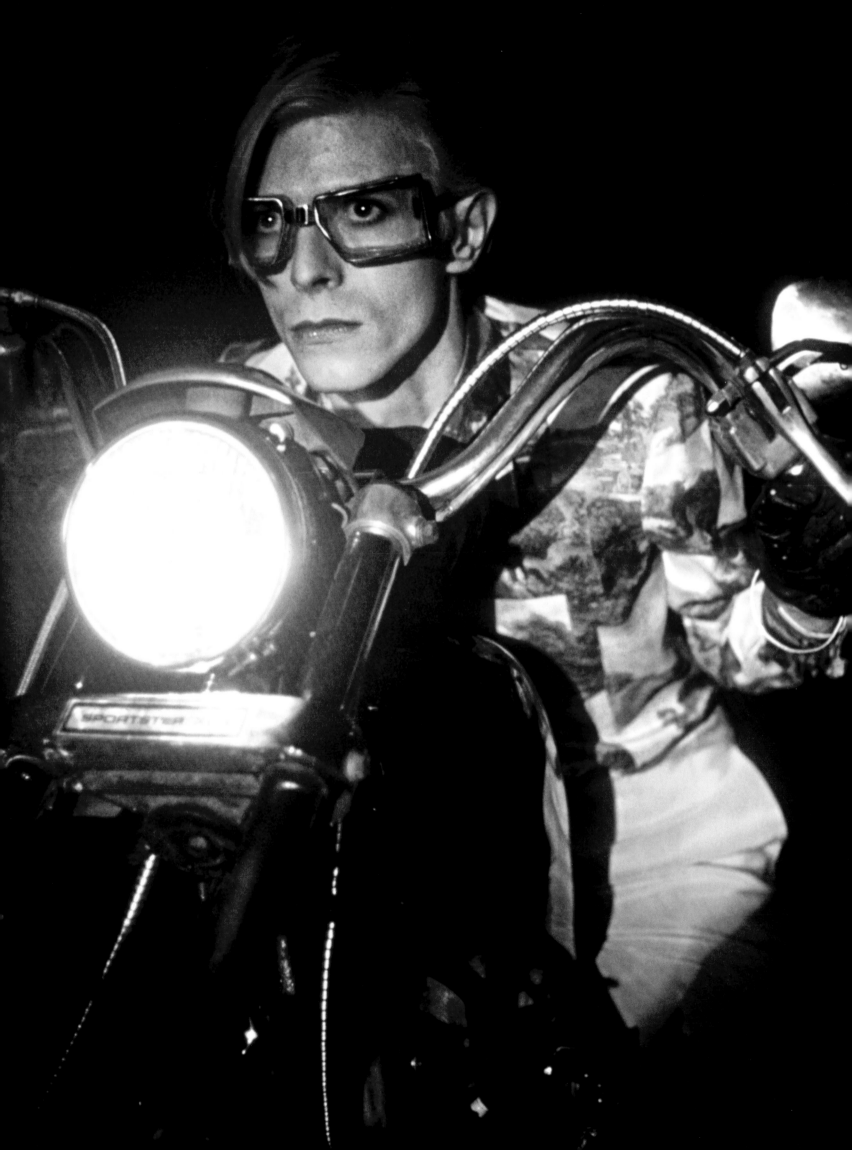

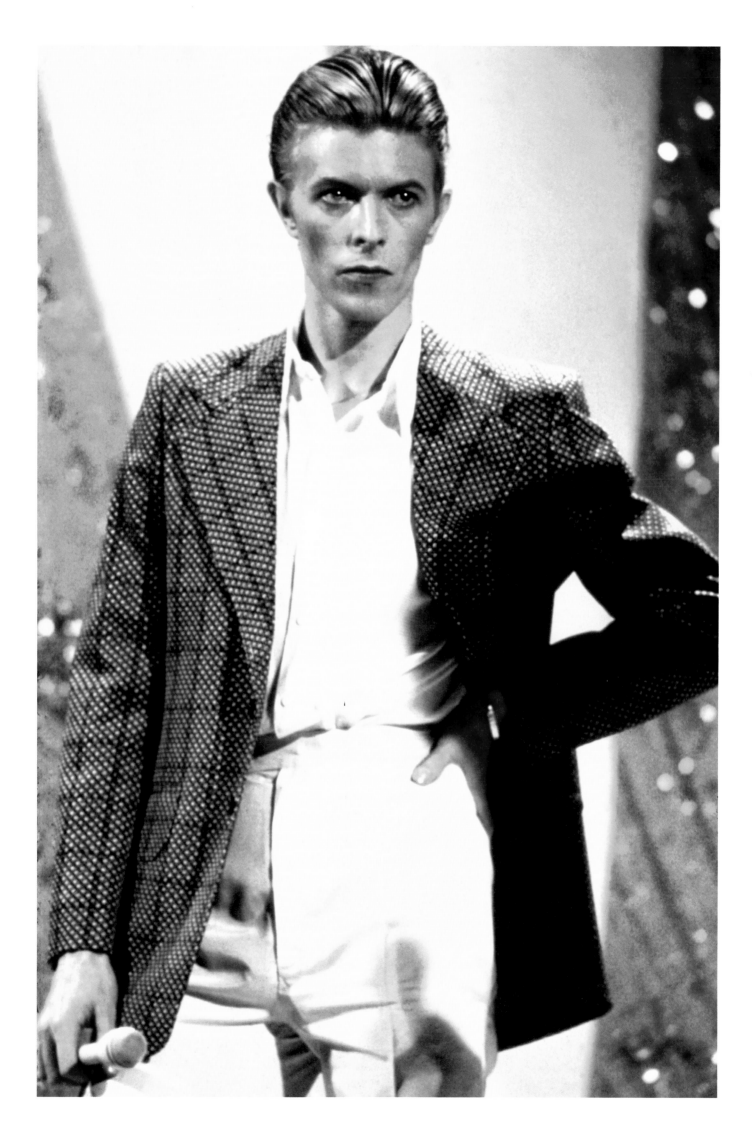

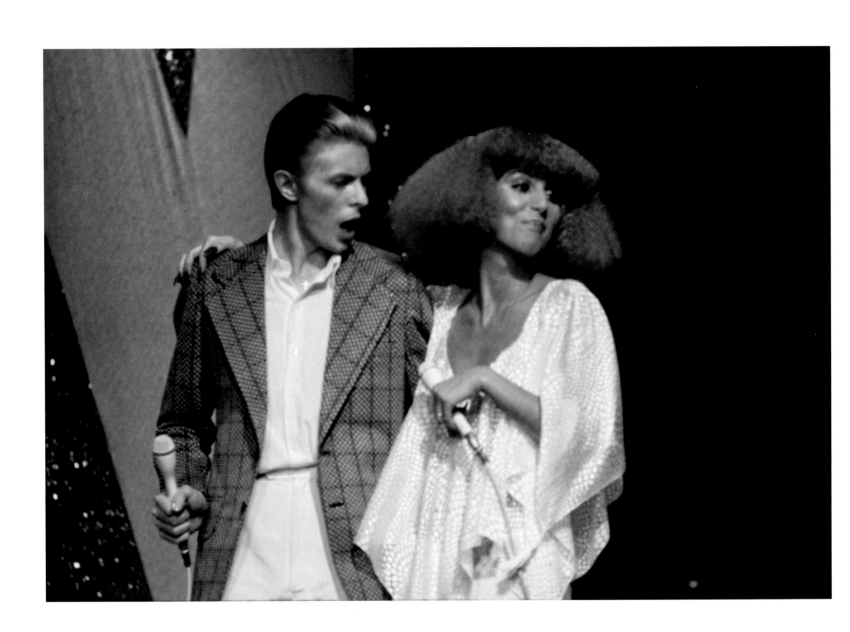

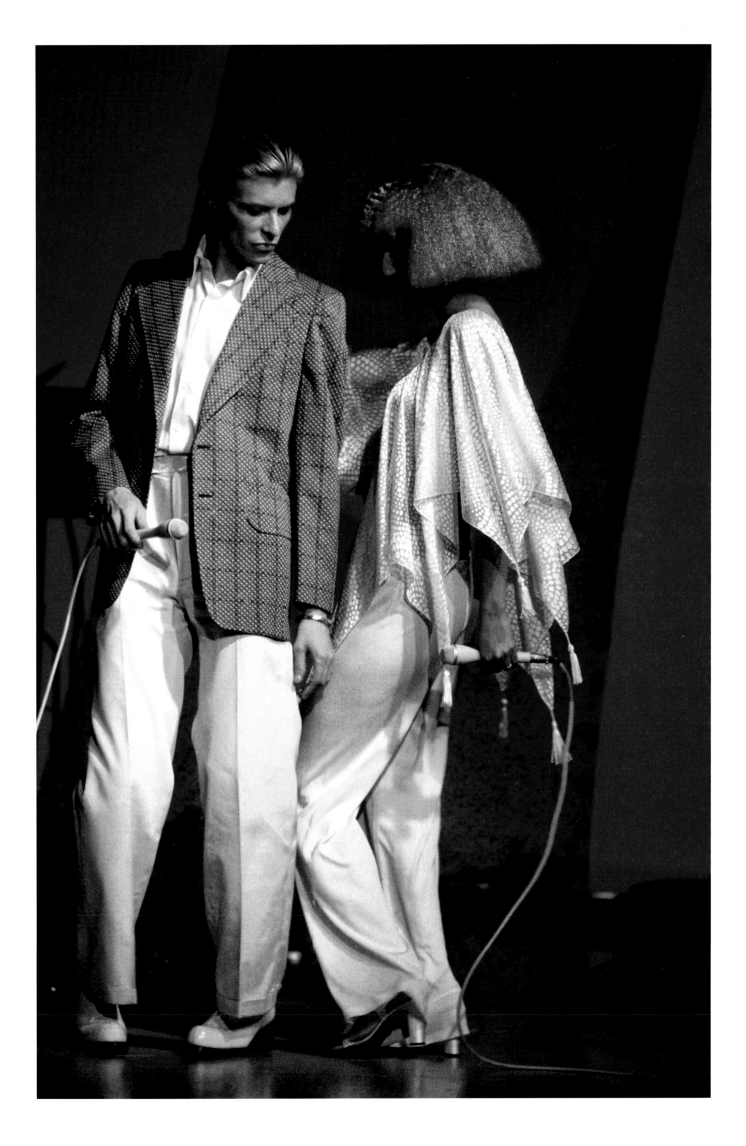

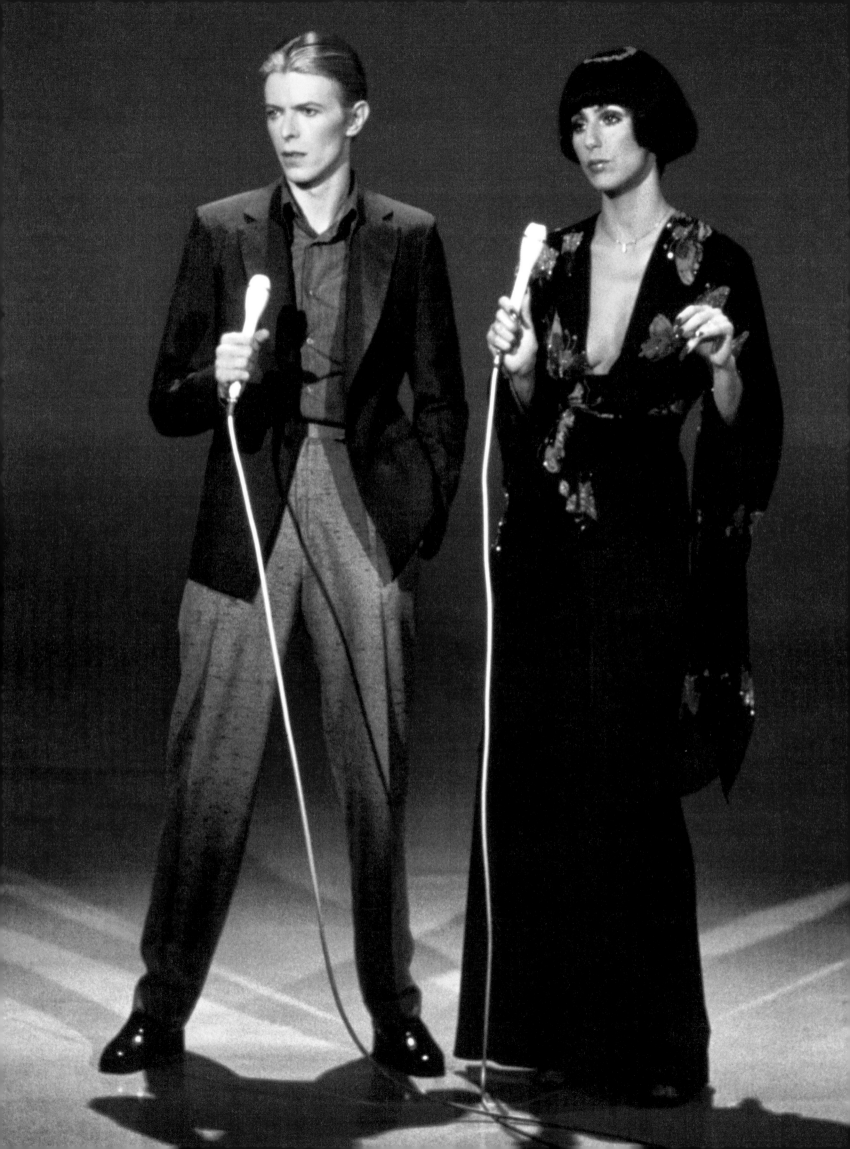

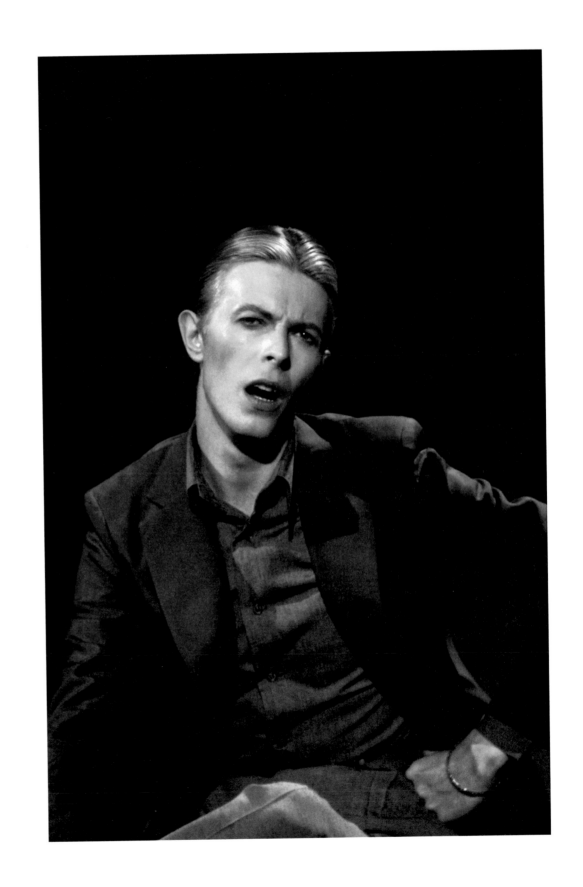

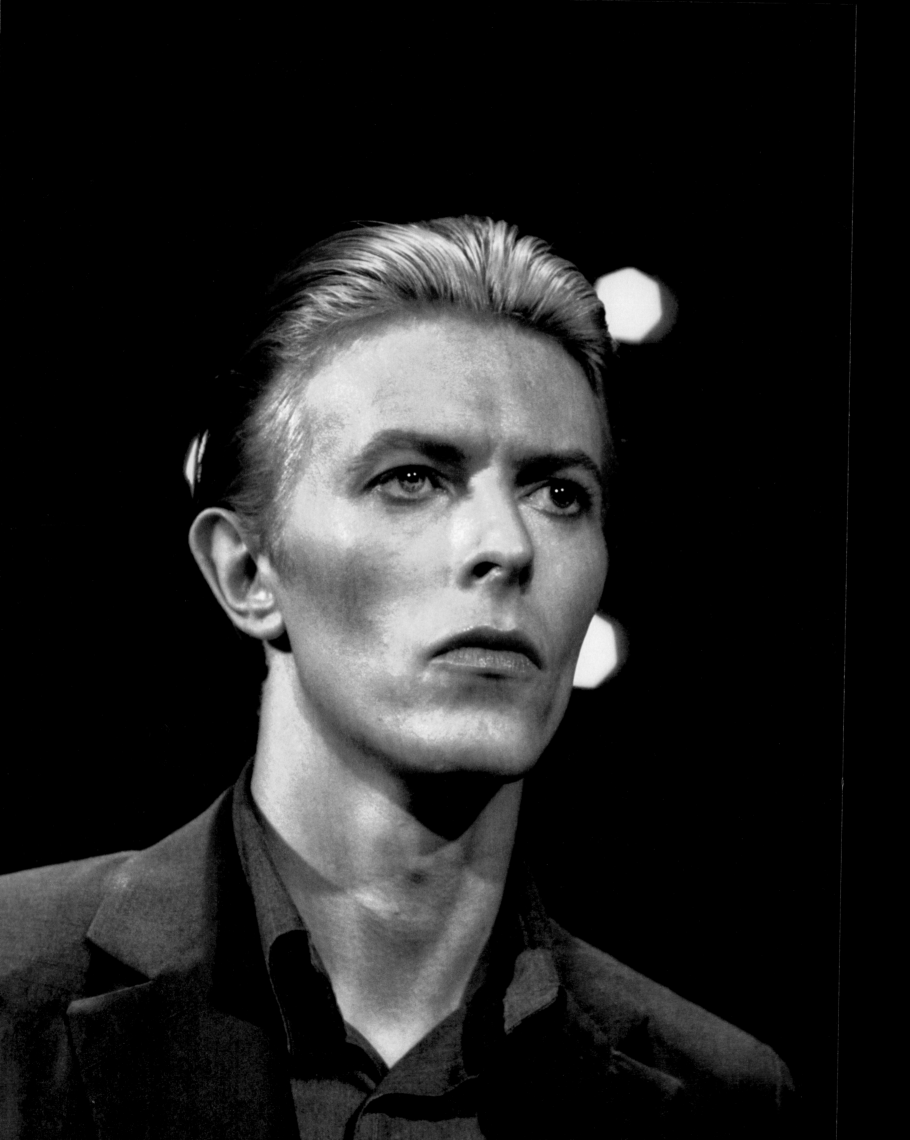

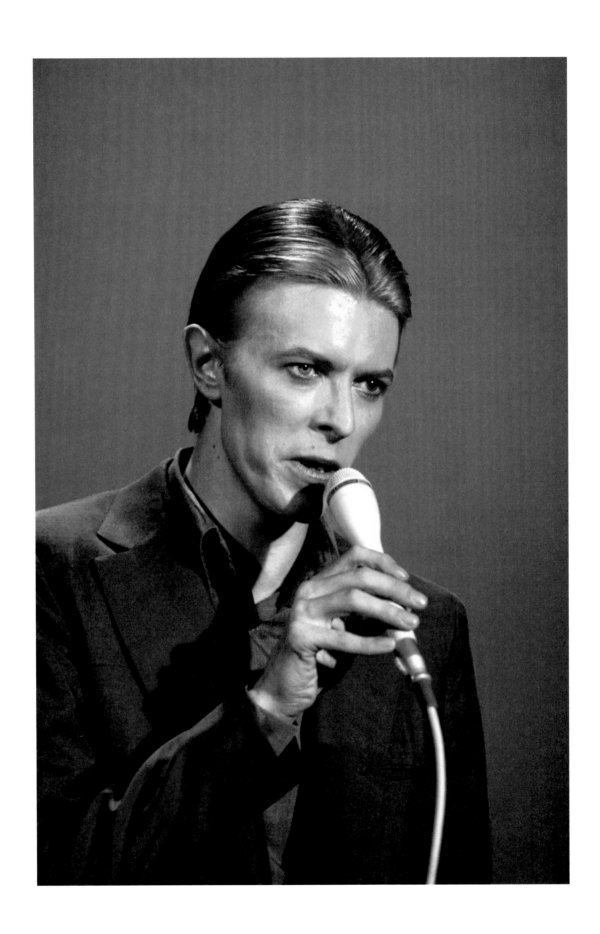

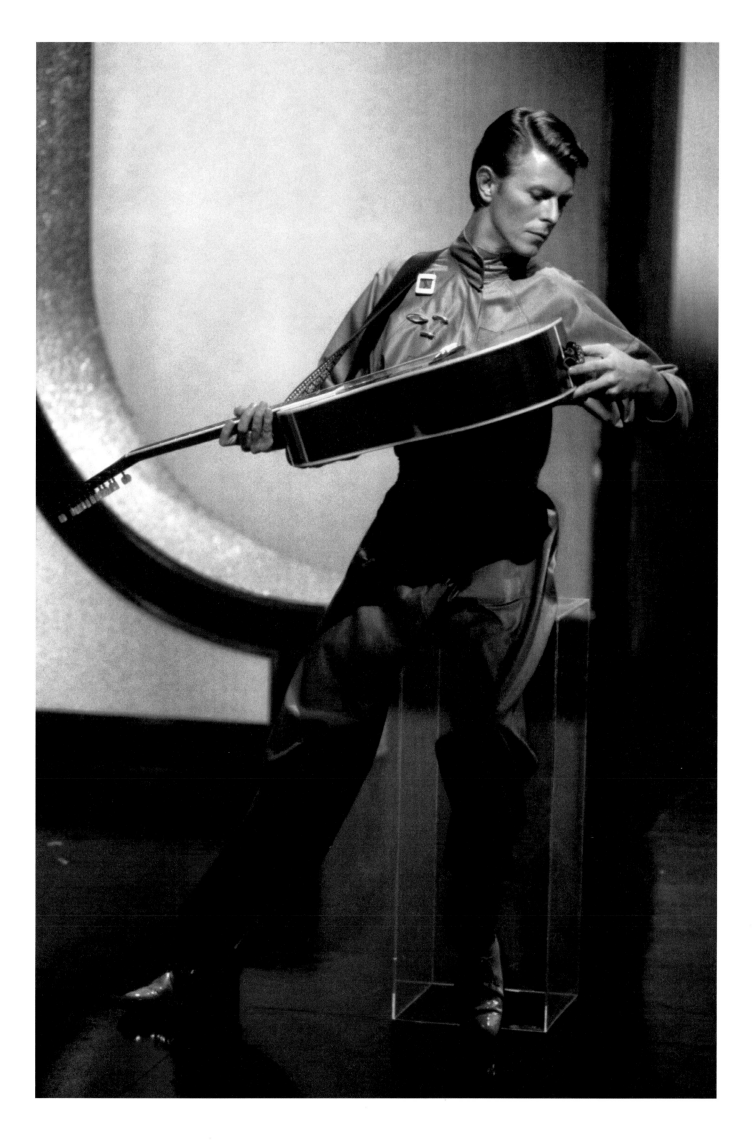

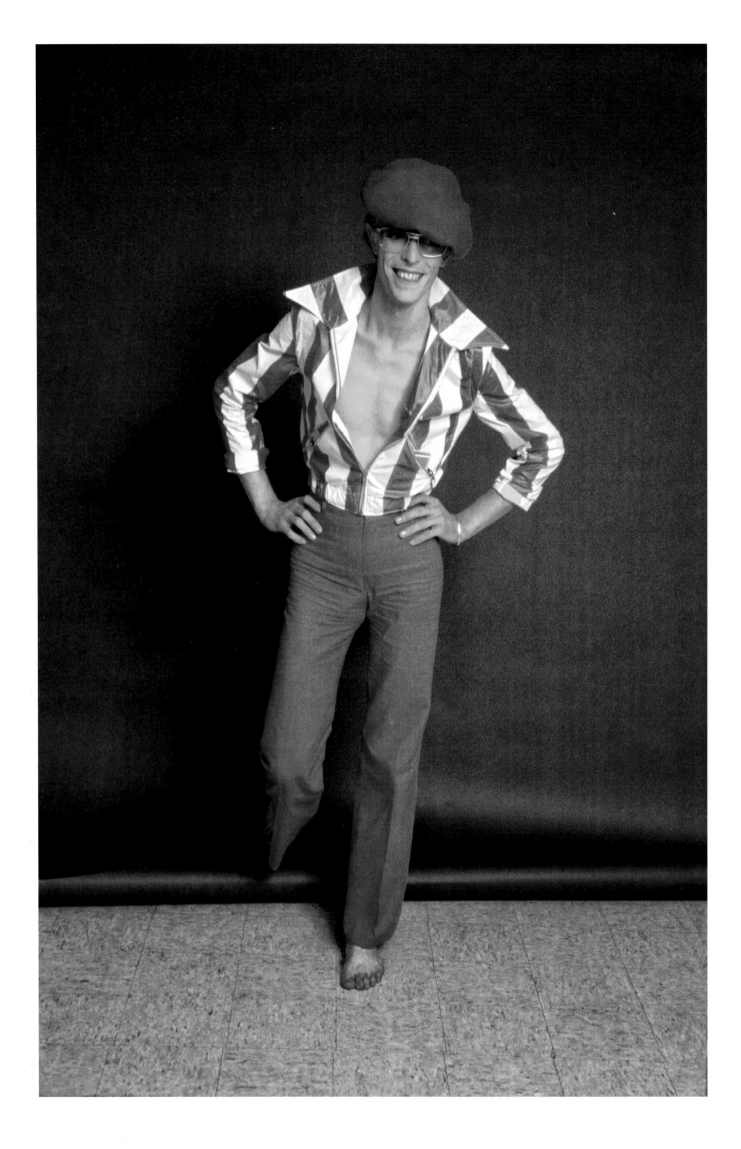

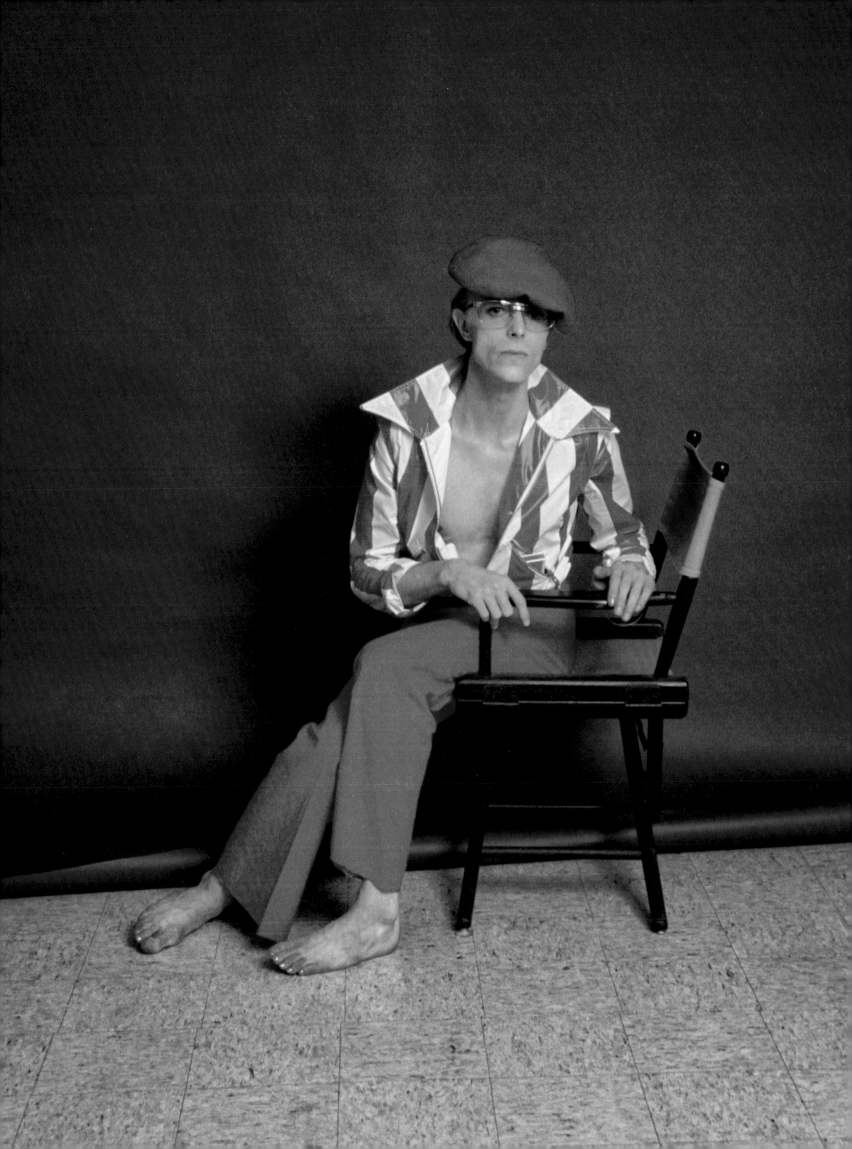

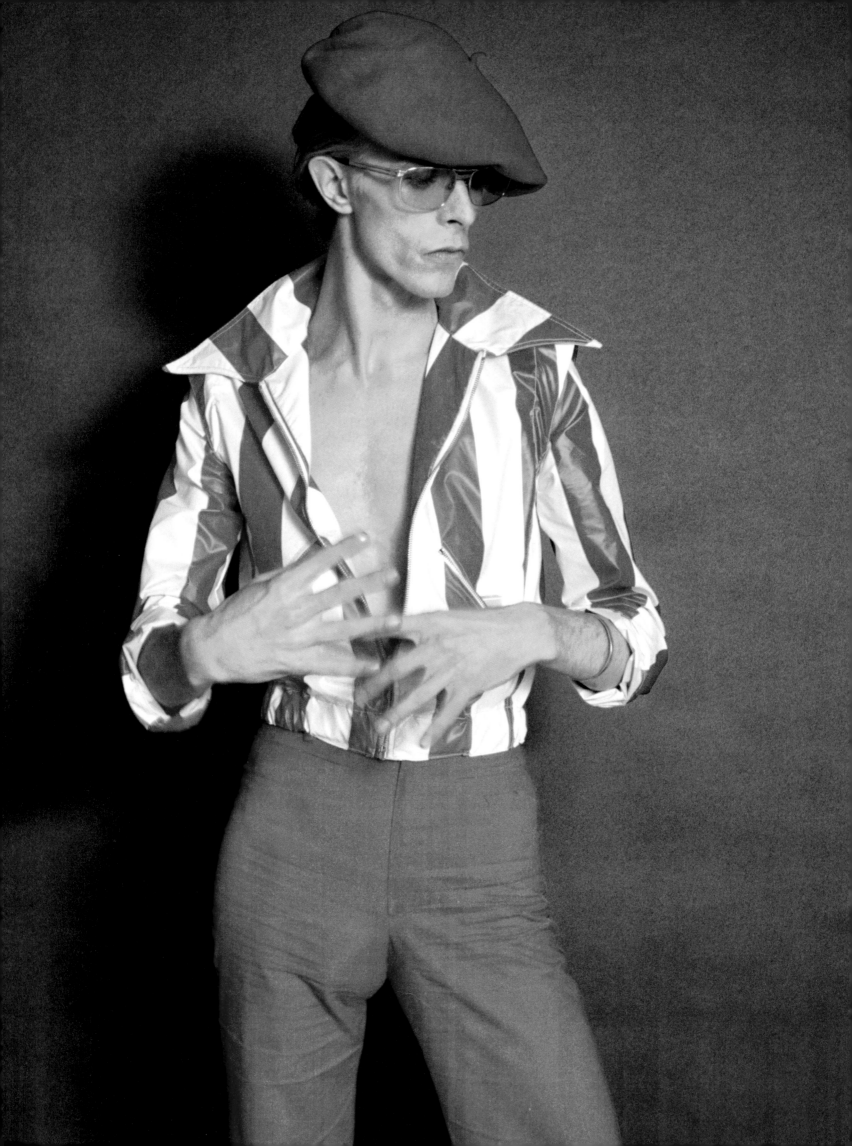

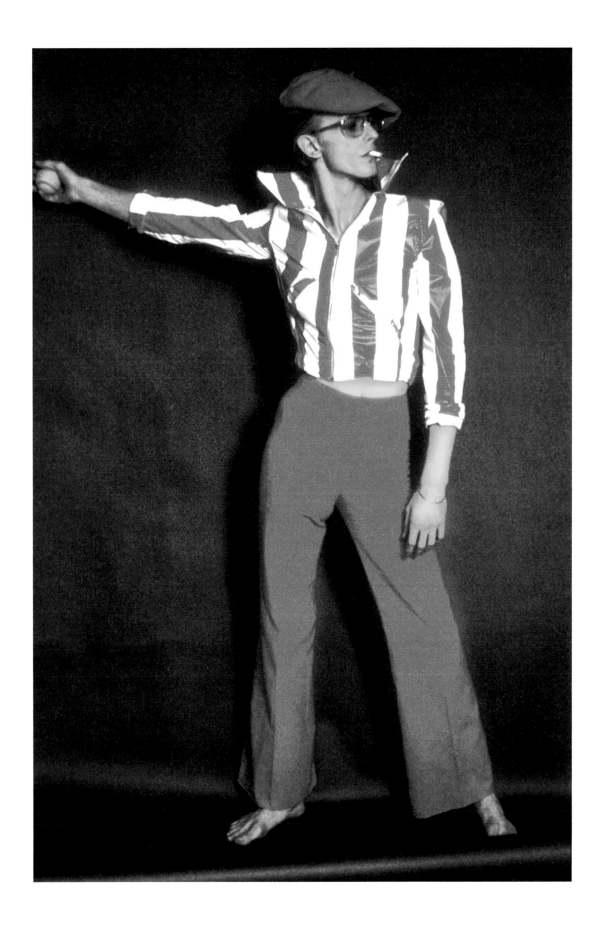

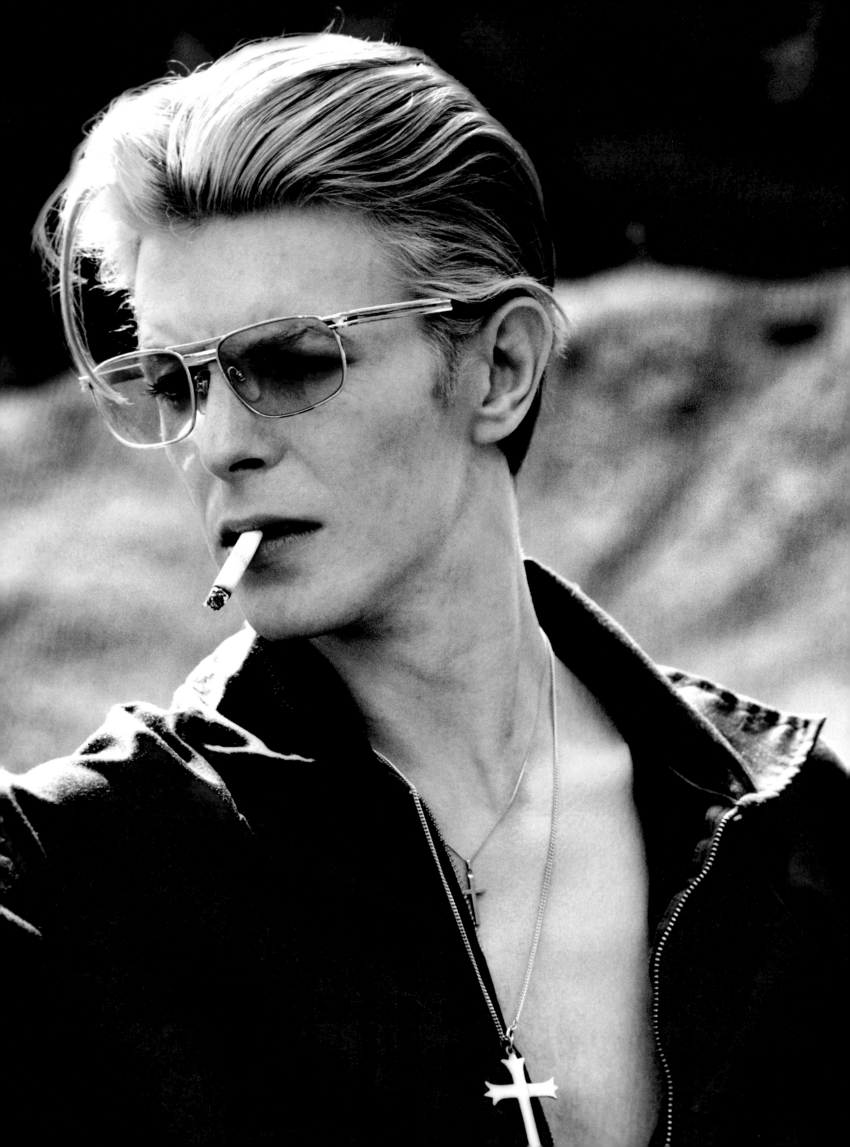

SM14170 FEBRUARY 12th, 1976/ISSUE NO. 206 85¢UK38

ROLLING STONE

DAVID BOWIE
*Rolling On
to Rule the World
By Cameron Crowe*

*Bent Waves and
Magic Twangers:*

SONIC BOOM
*Musical Instruments
for Everyone*
- *The Rolling Stone
Interview: CHET ATKINS*
- *Axes of the Aces:
HERBIE HANCOCK,
RICHARD CARPENTER,
STEVIE WONDER*
- *Leo Fender: Henry Ford
of the Solid Body*

Has

THE MOB
*Put the Lean
on 'Penthouse' Magazine?*

FORD'S RESIGNATION SPEECH
EXCLUSIVE TEXT

14023

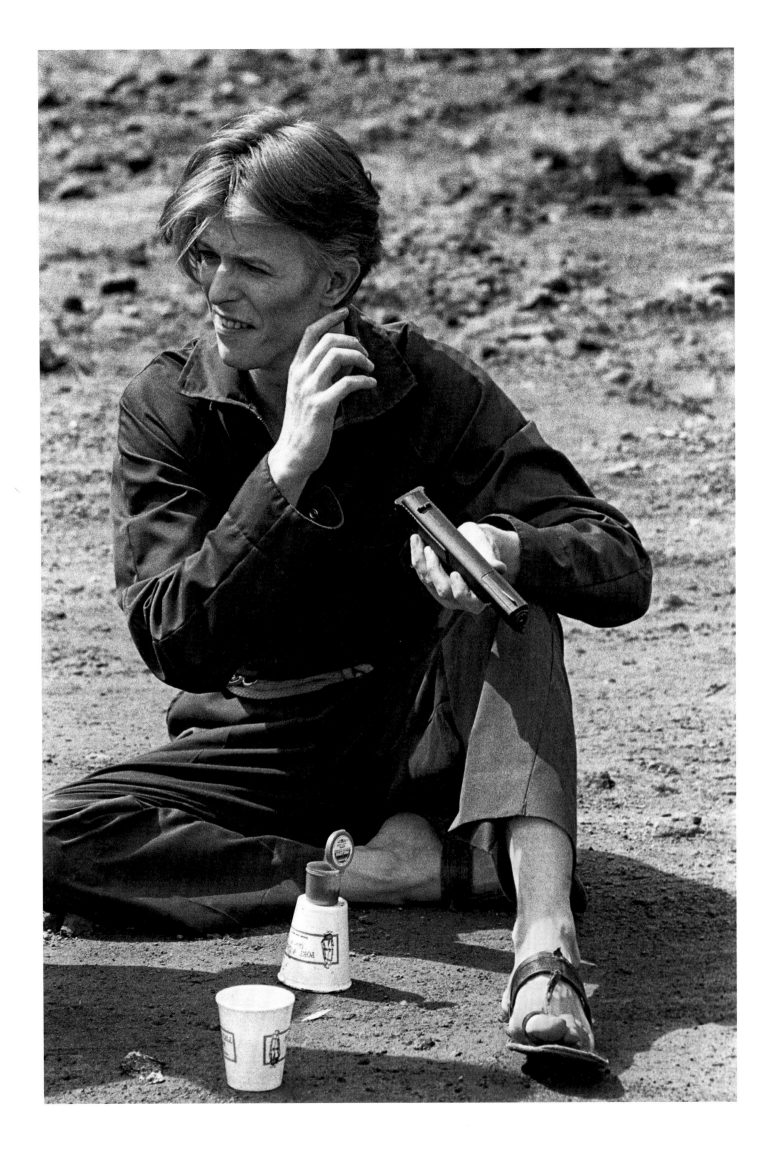

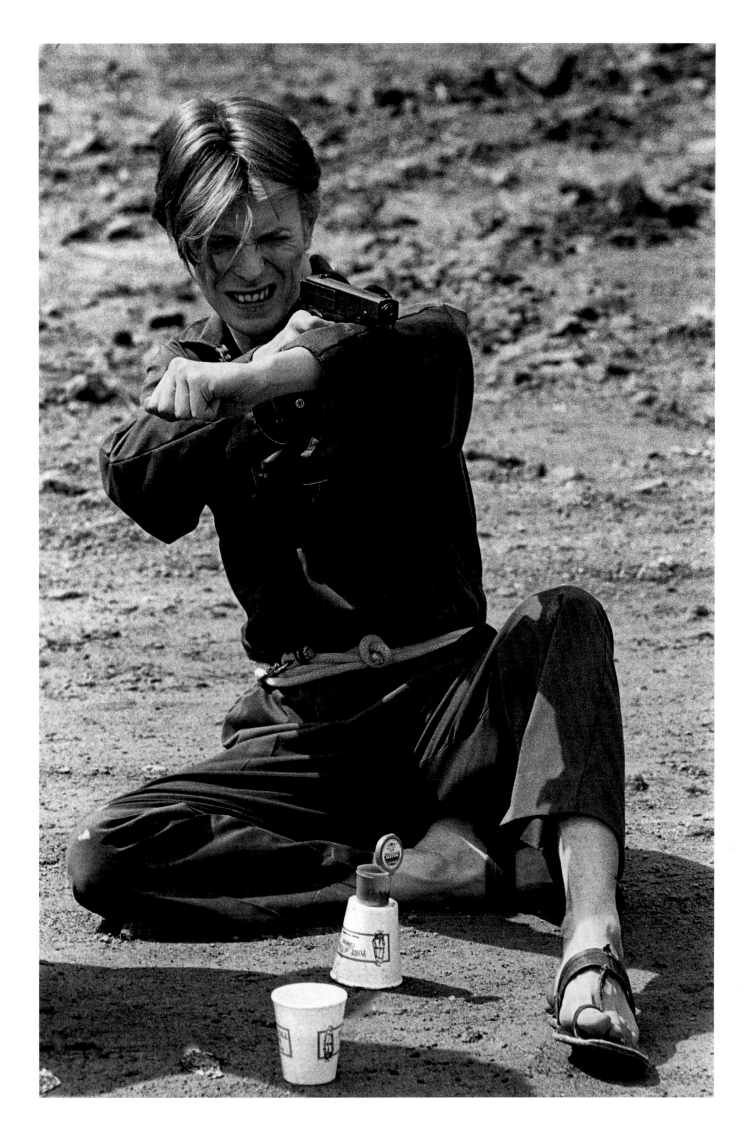

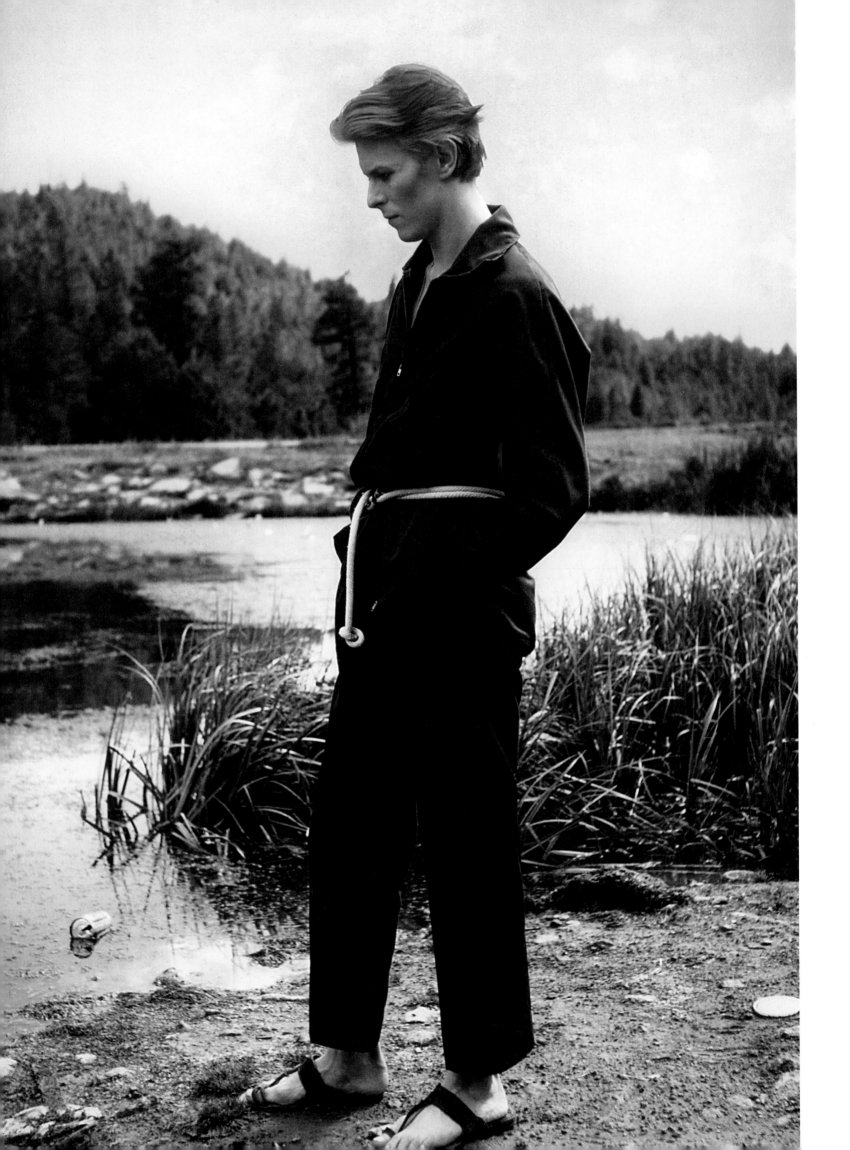

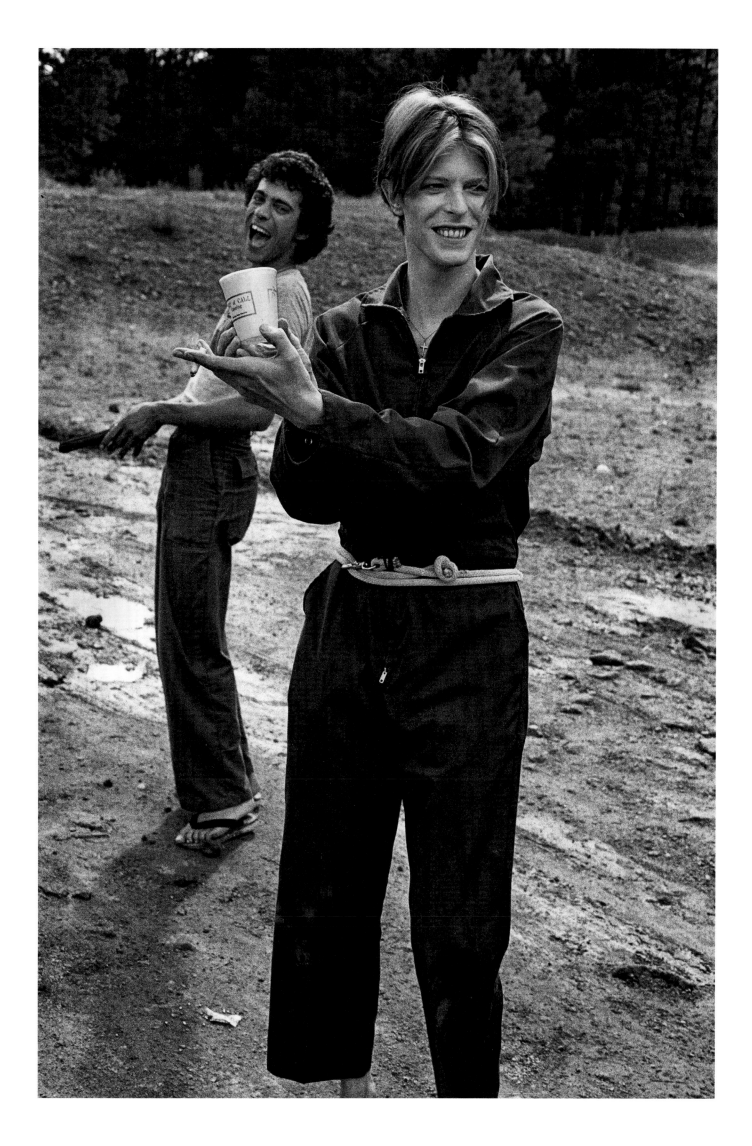

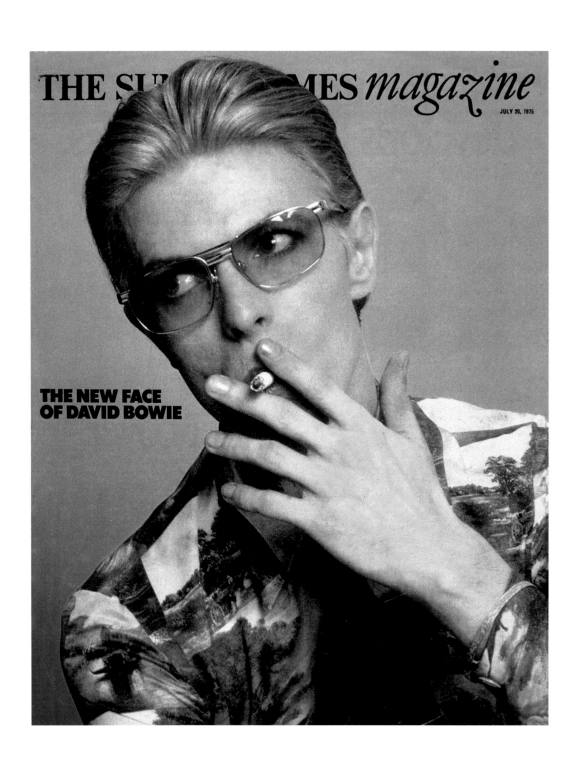

THE SU... ...MES *magazine*

JULY 20, 1975

THE NEW FACE
OF DAVID BOWIE

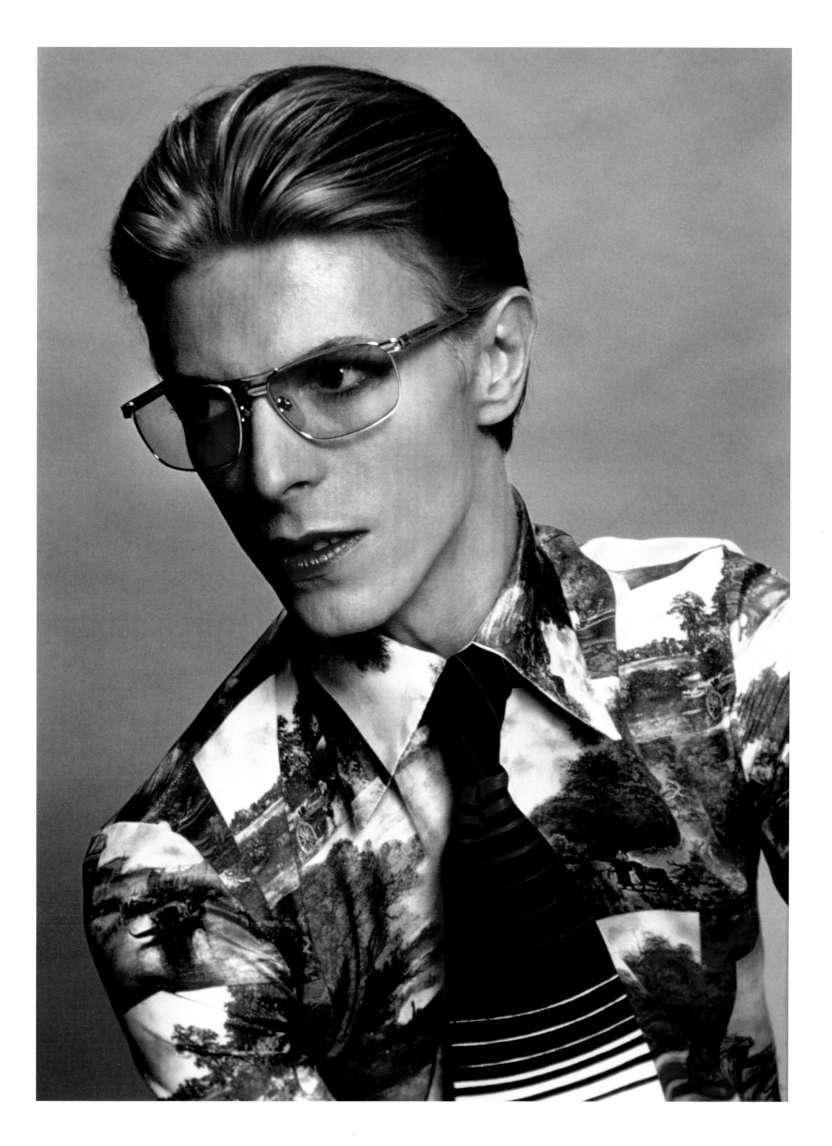

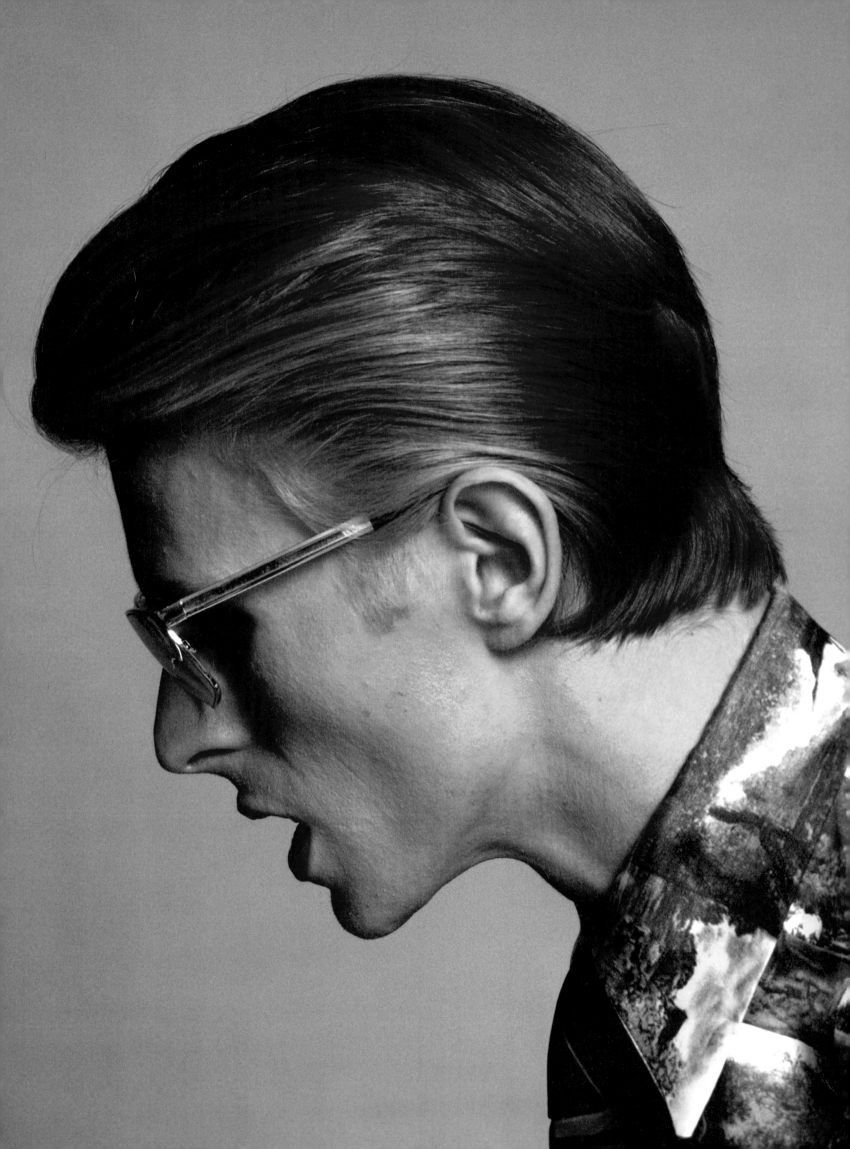

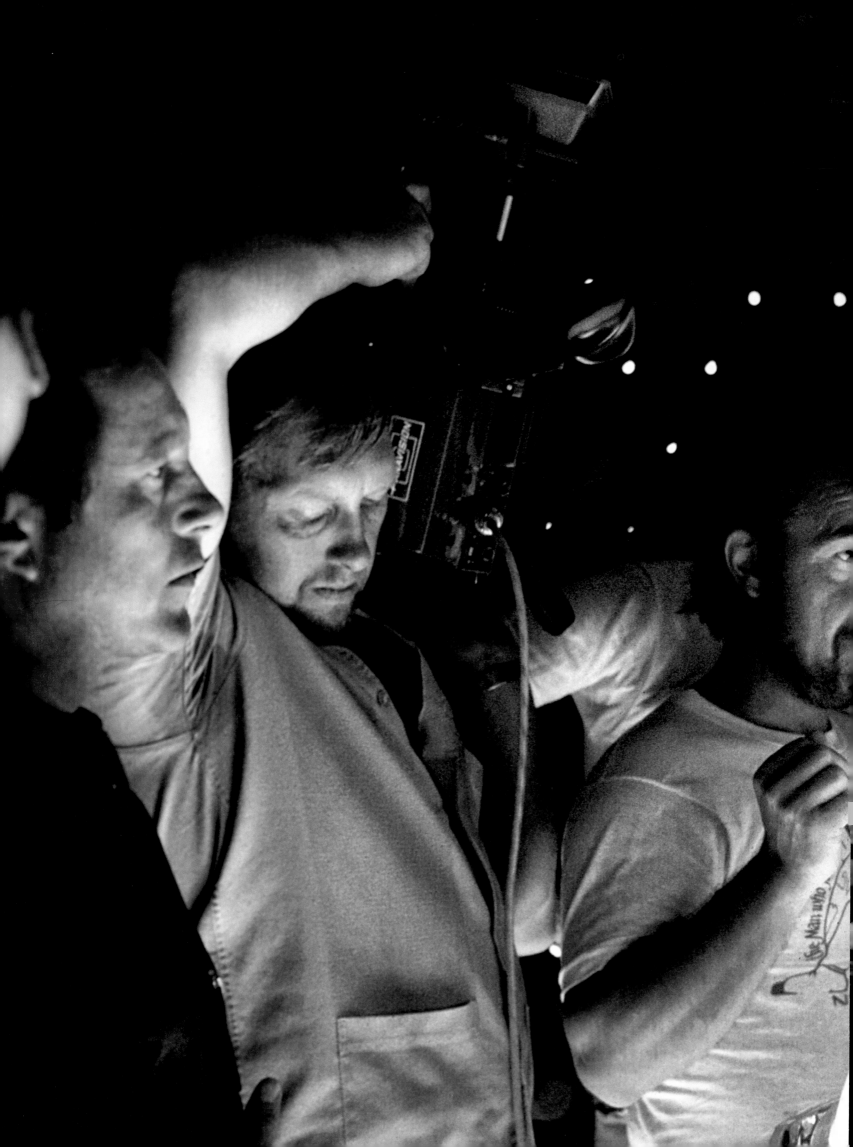

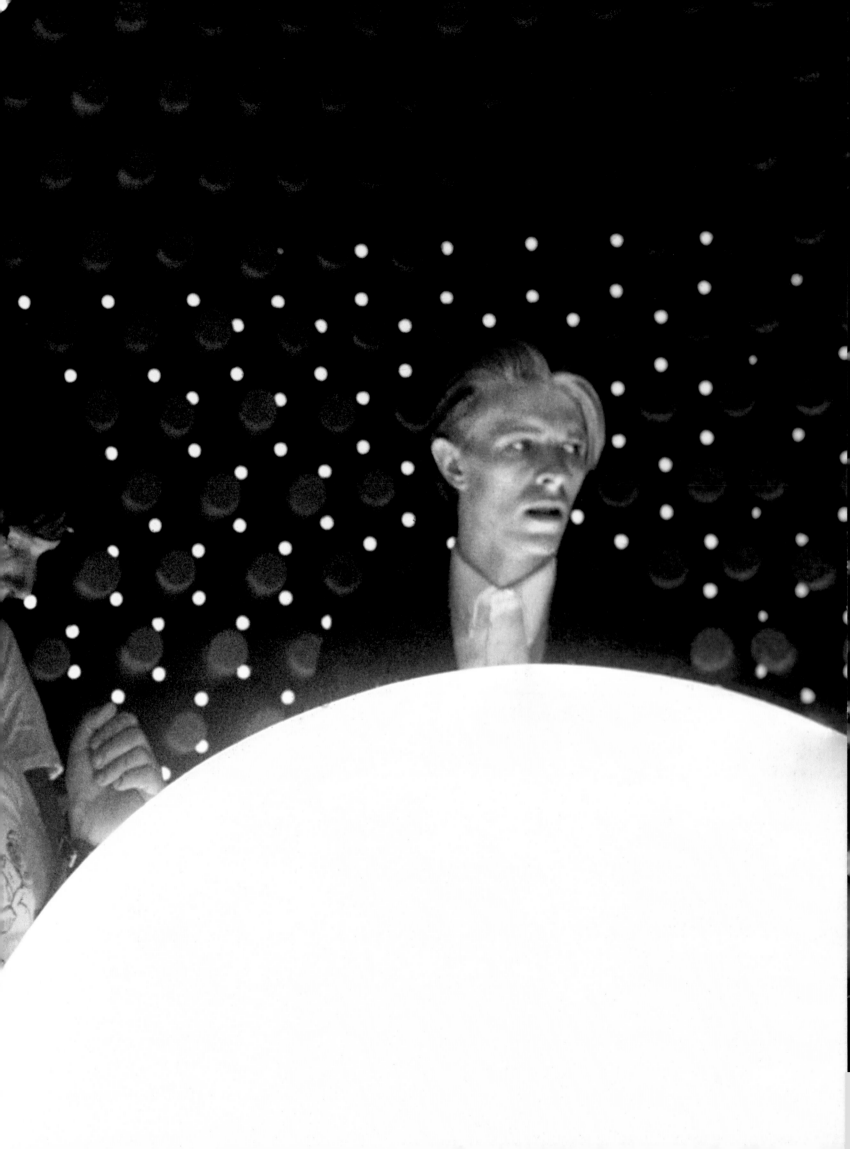

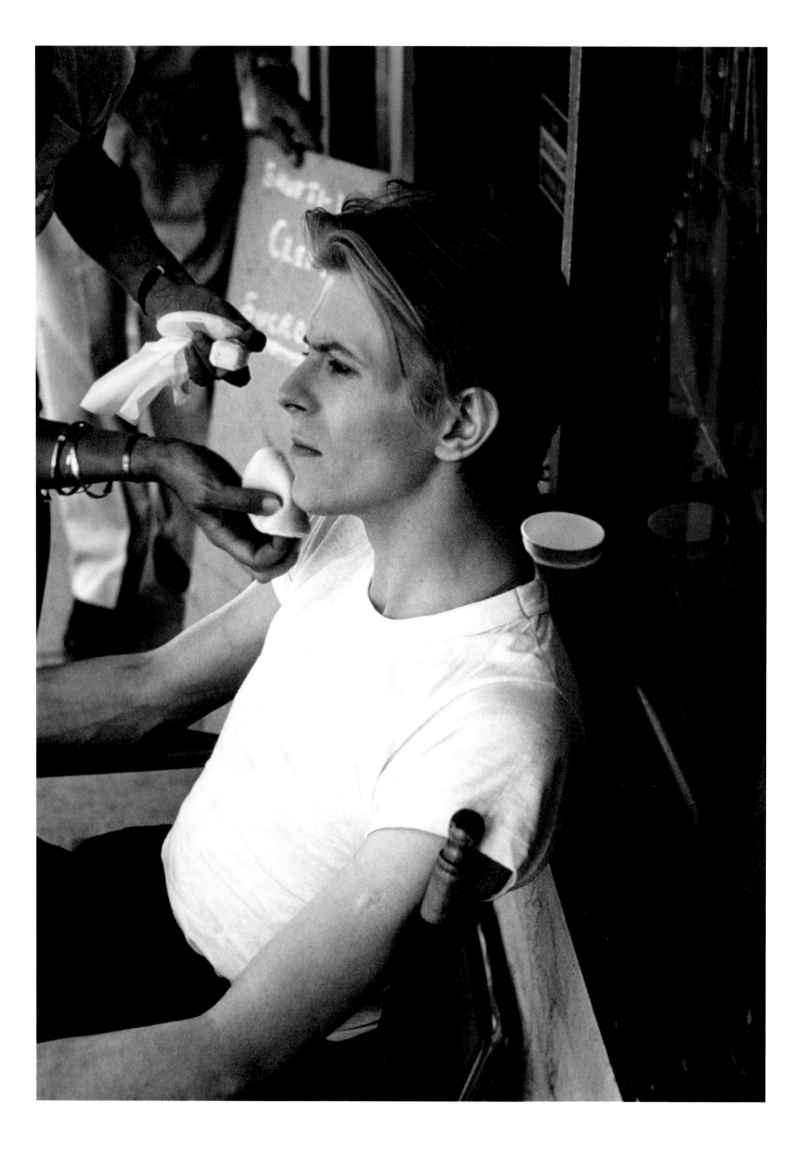

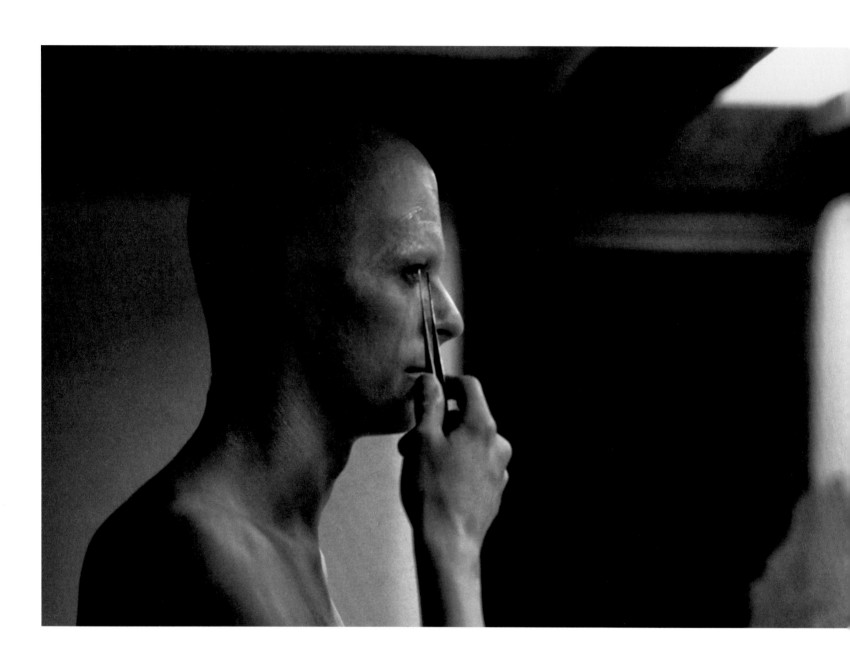

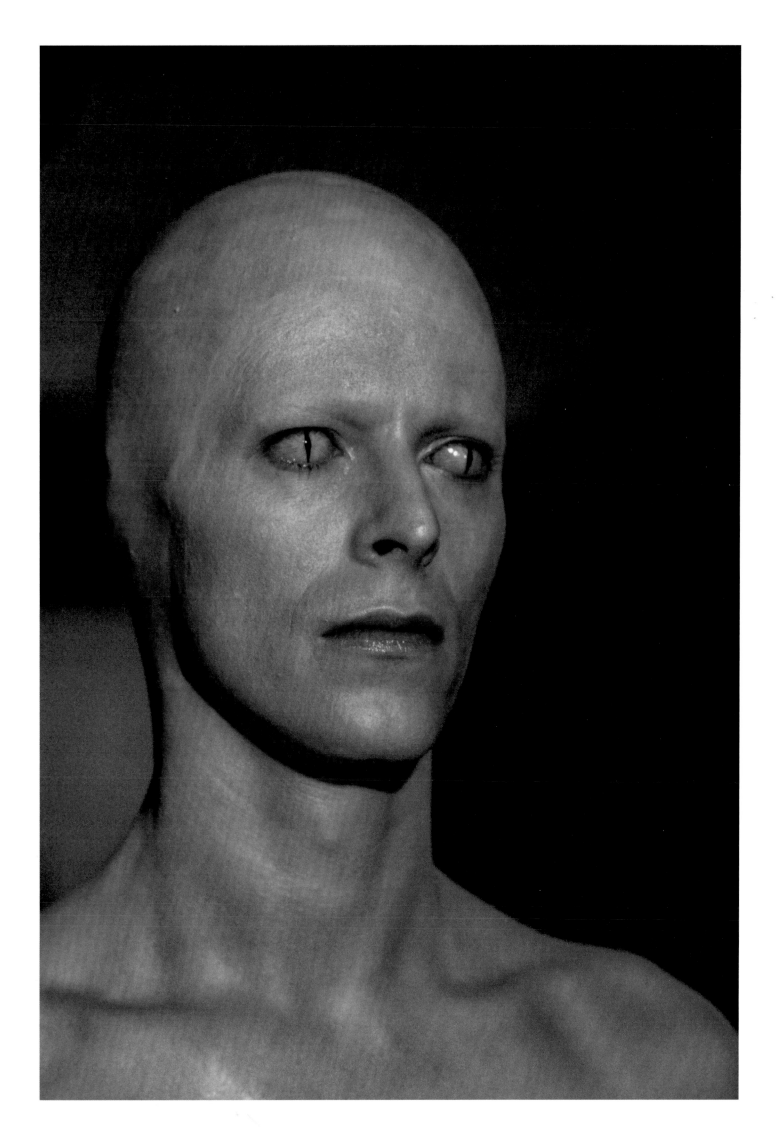

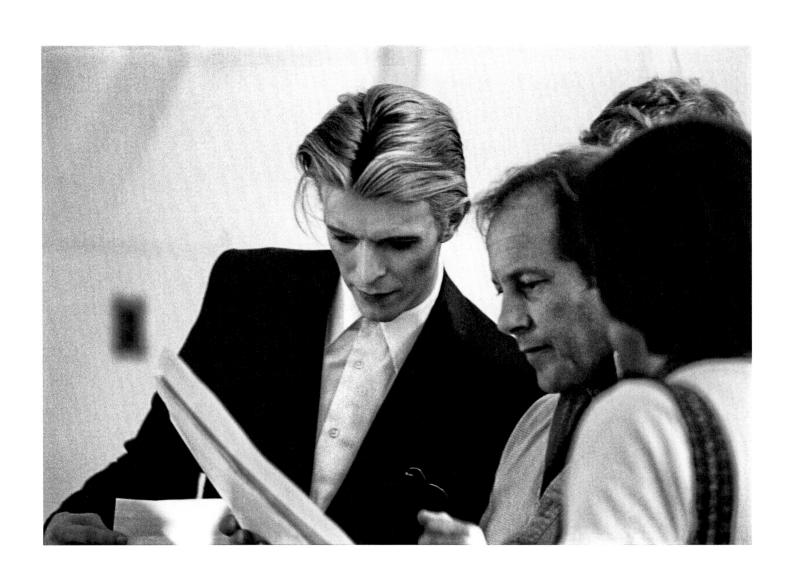

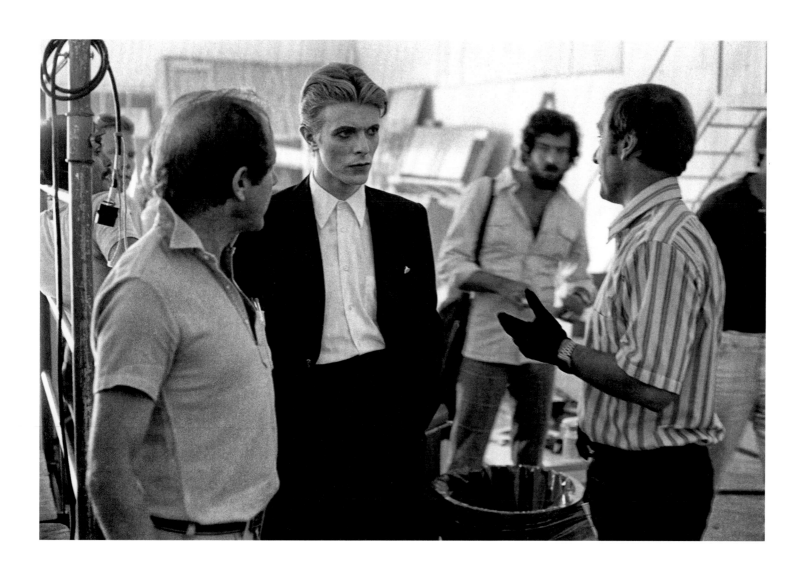

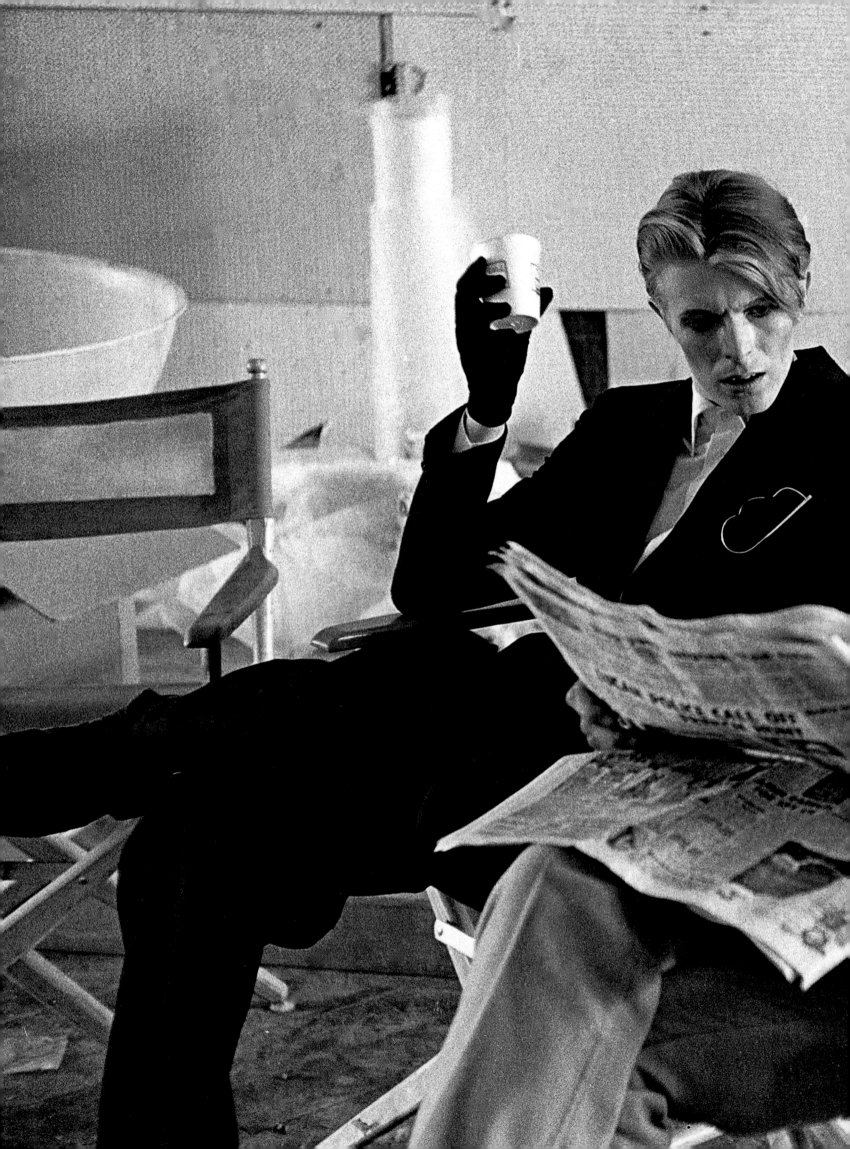

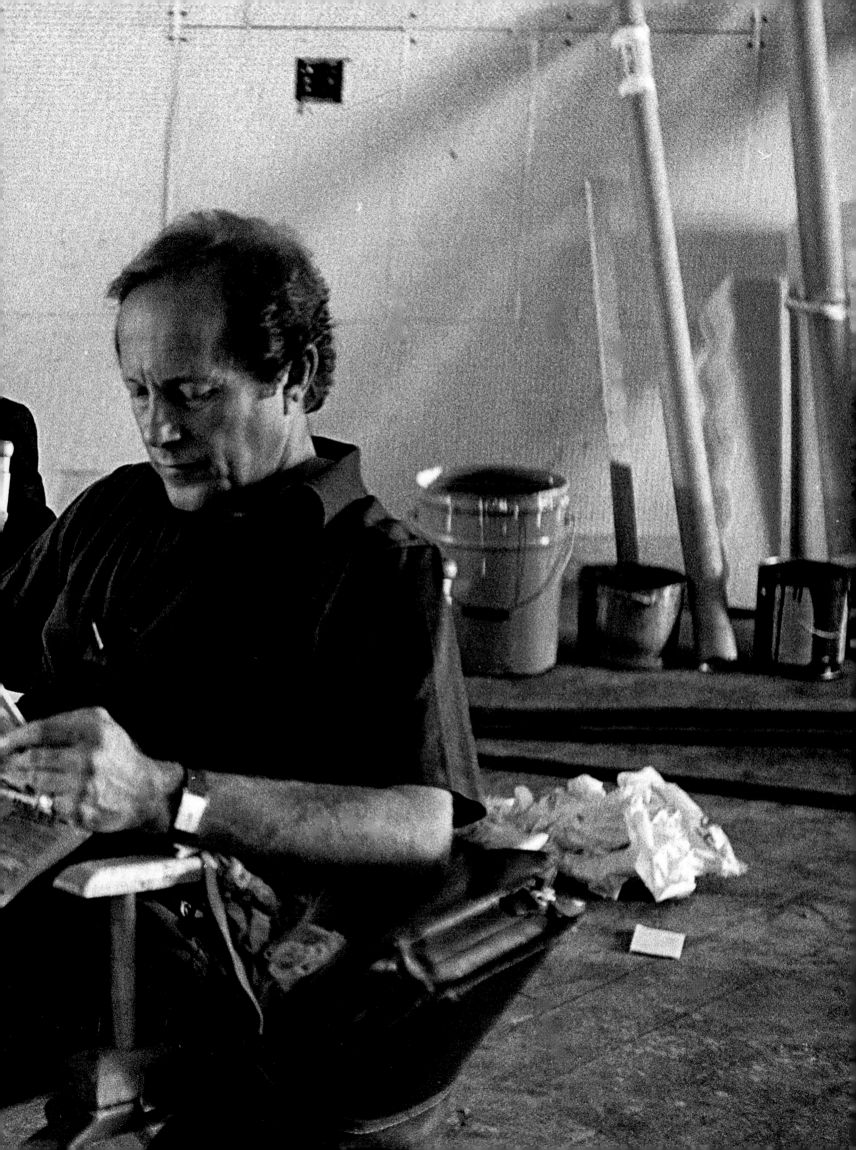

STATIONTOSTATIONDAVIDBOWIE

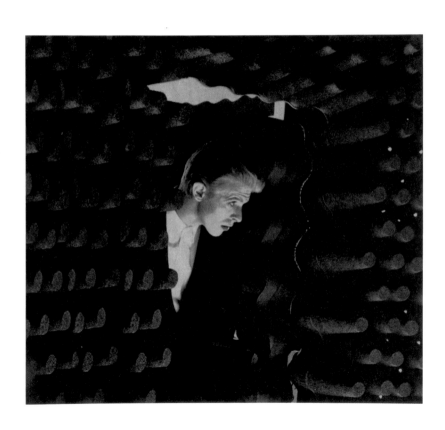

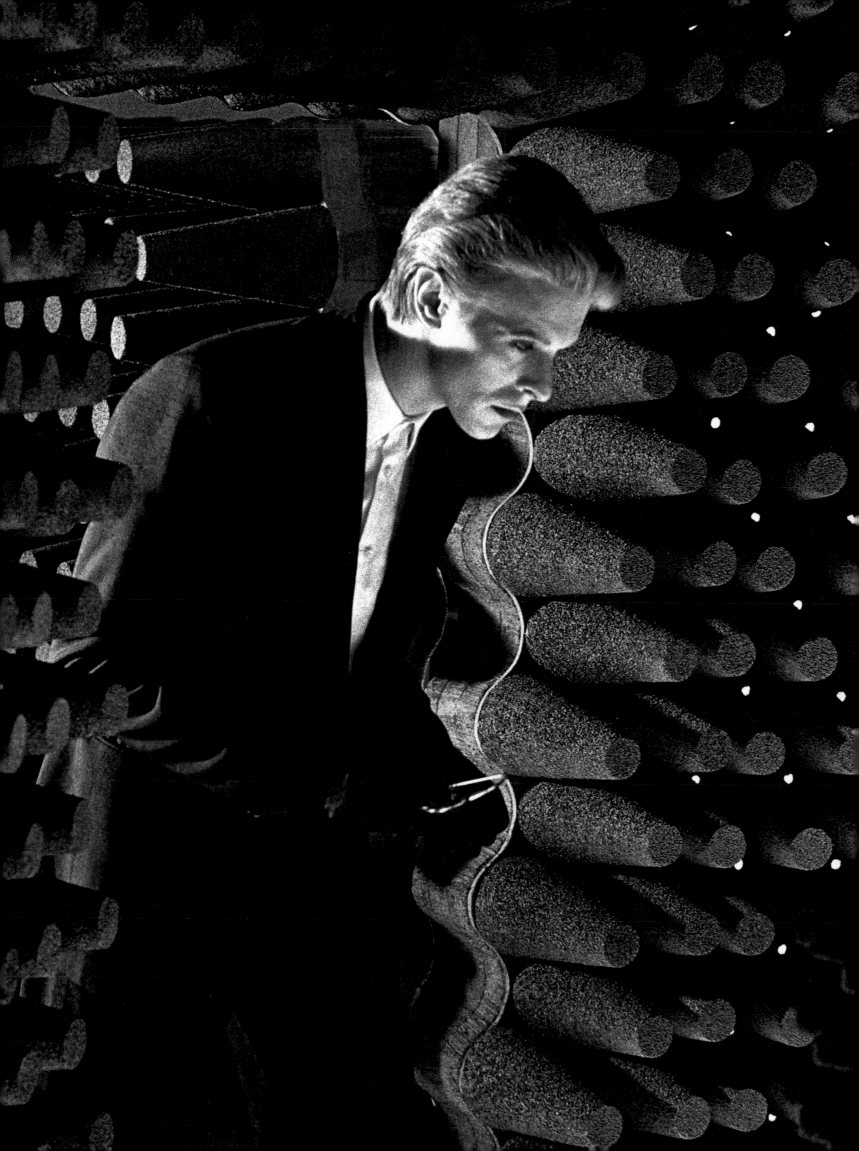

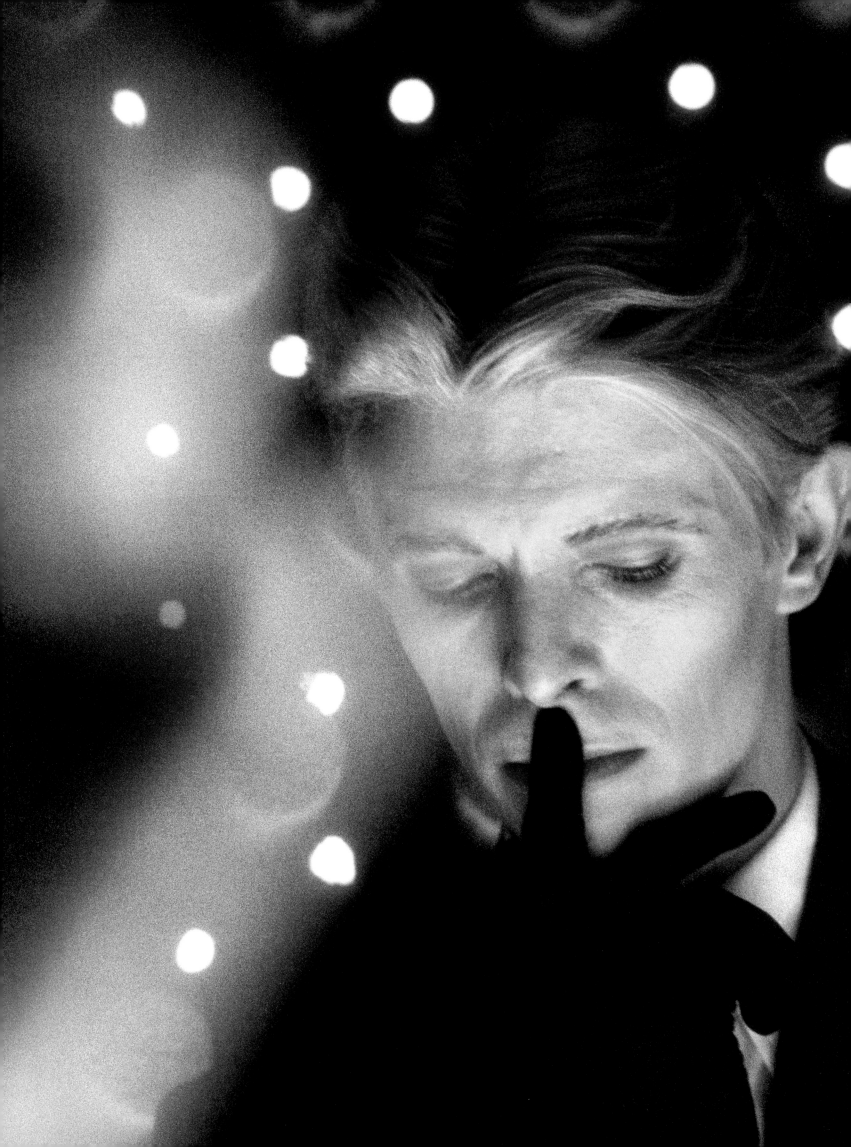

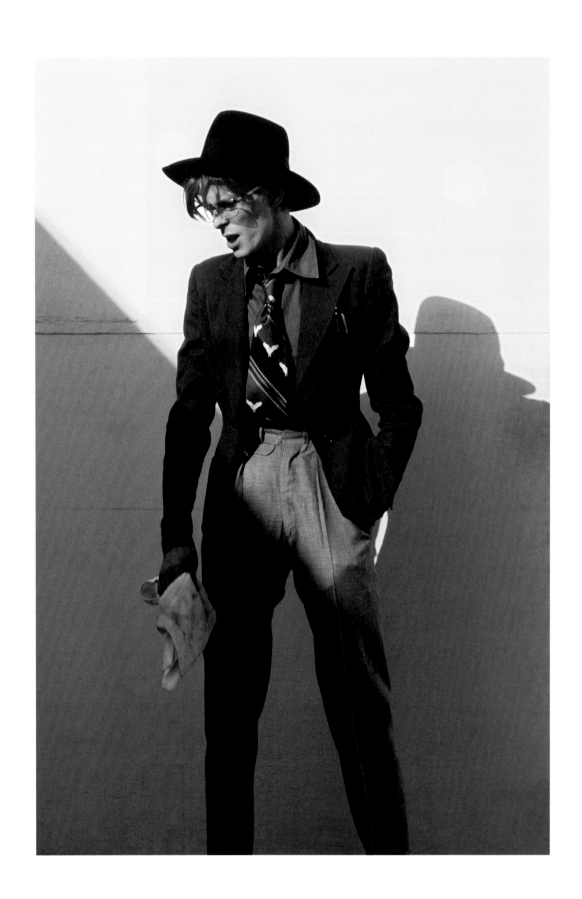

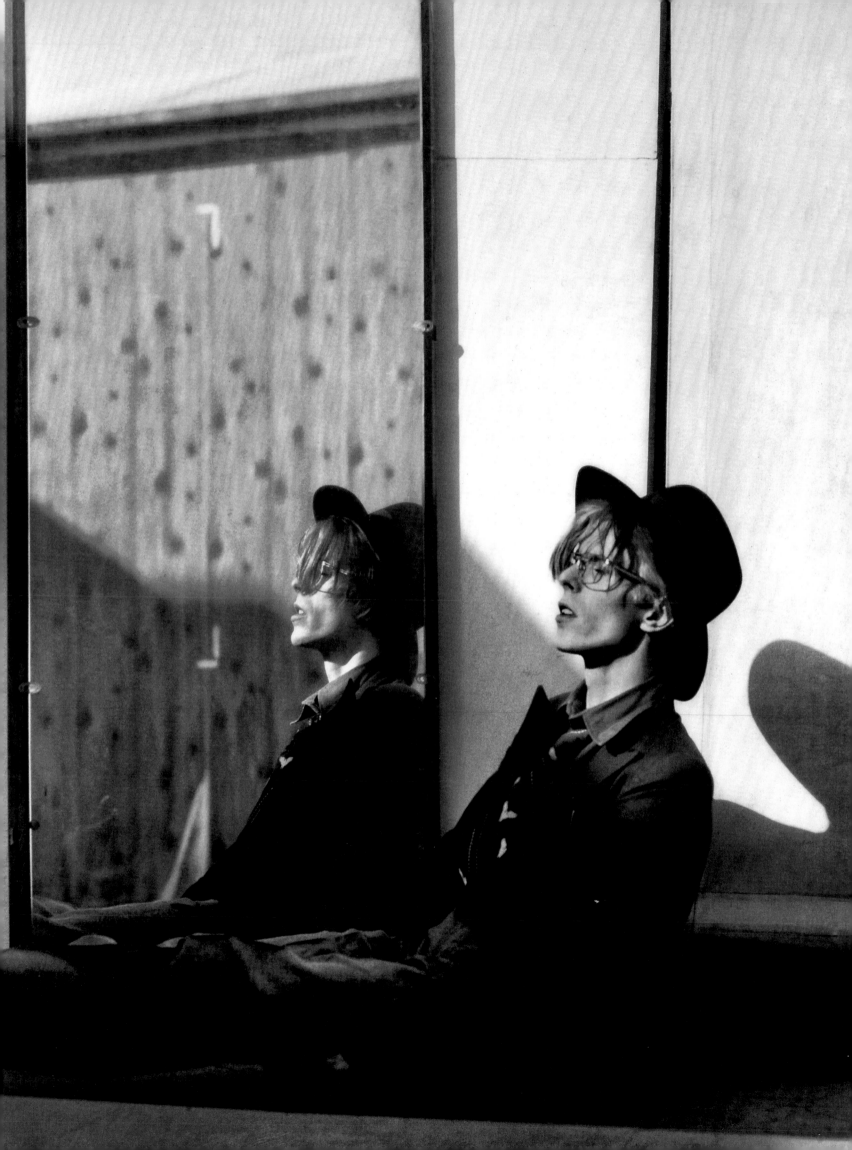

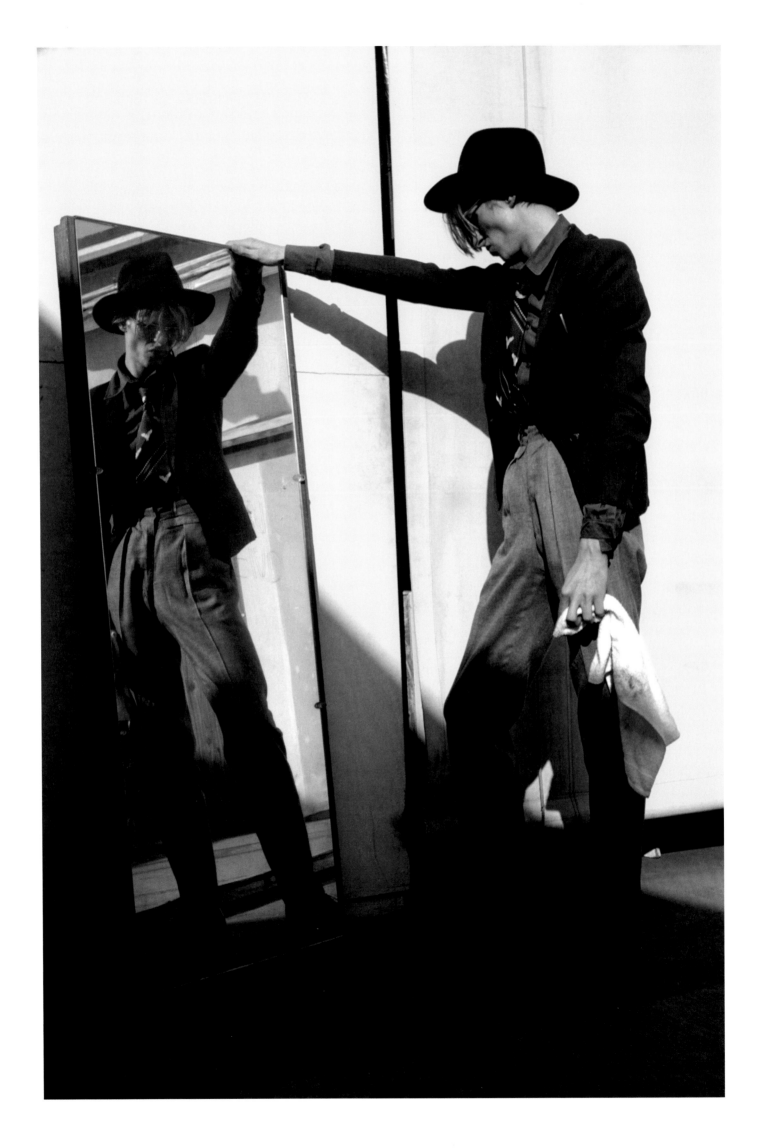

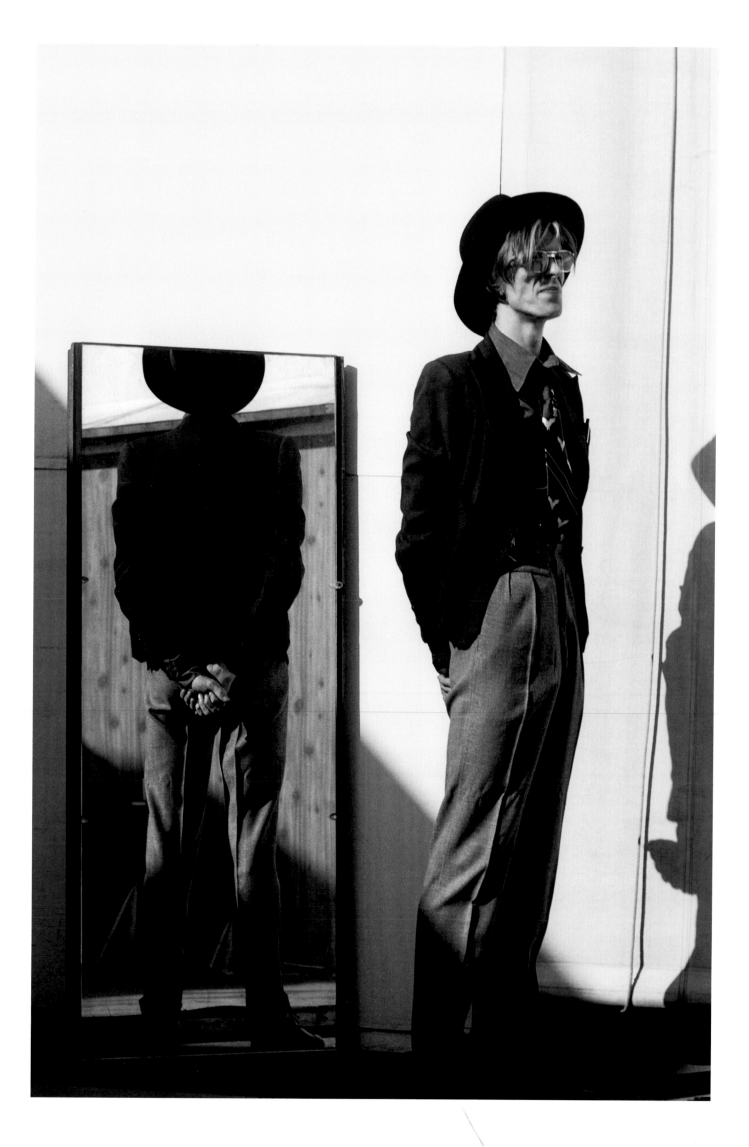

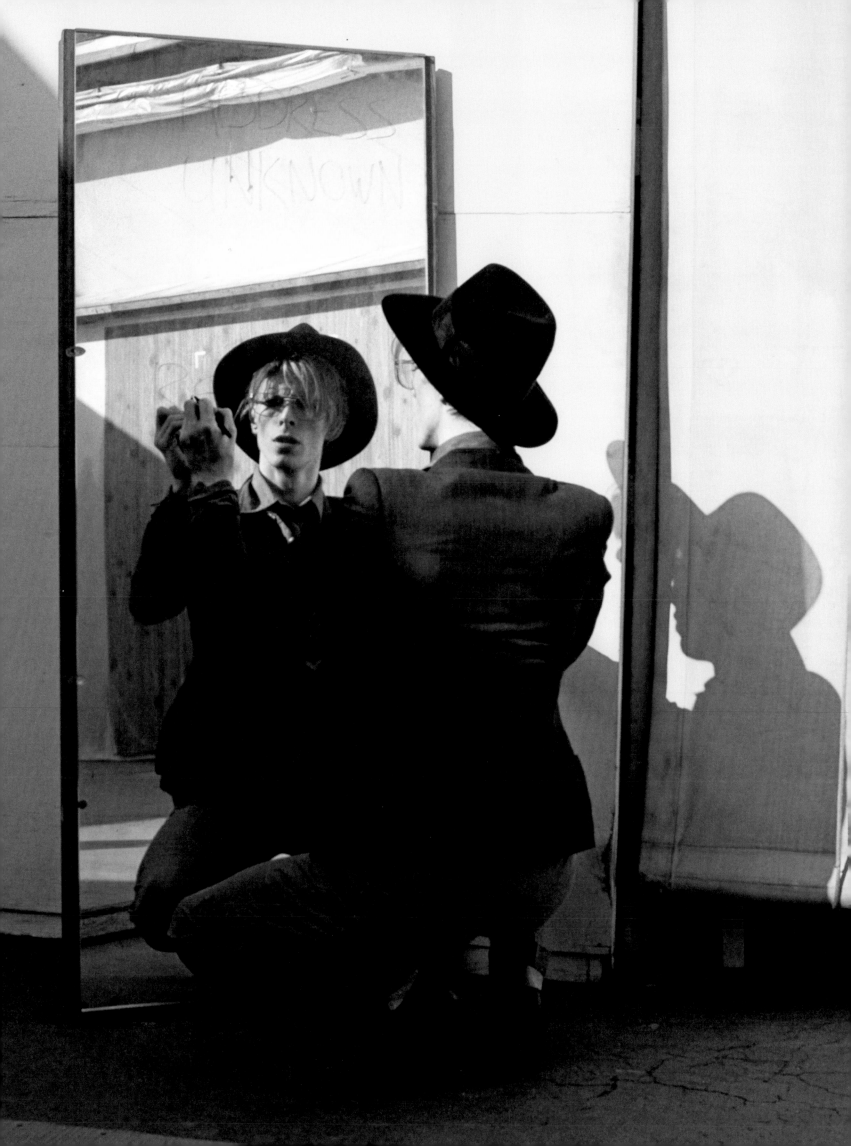

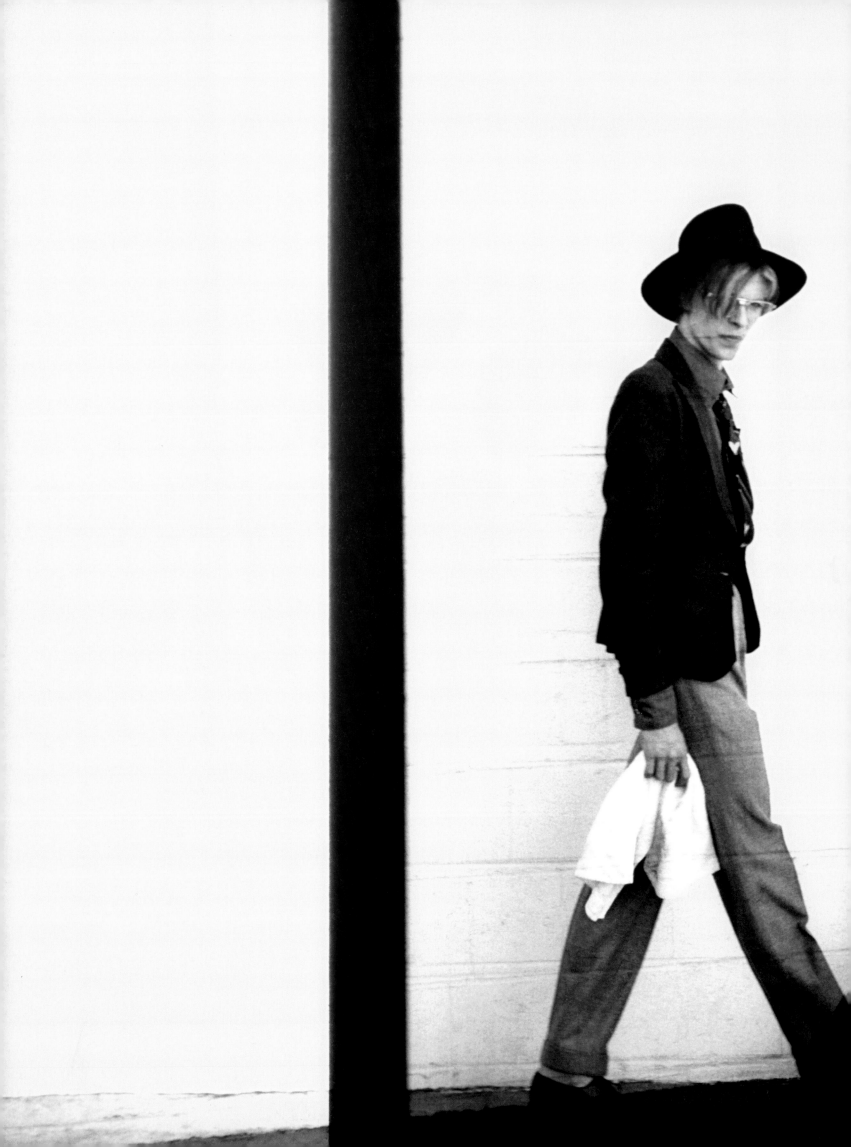

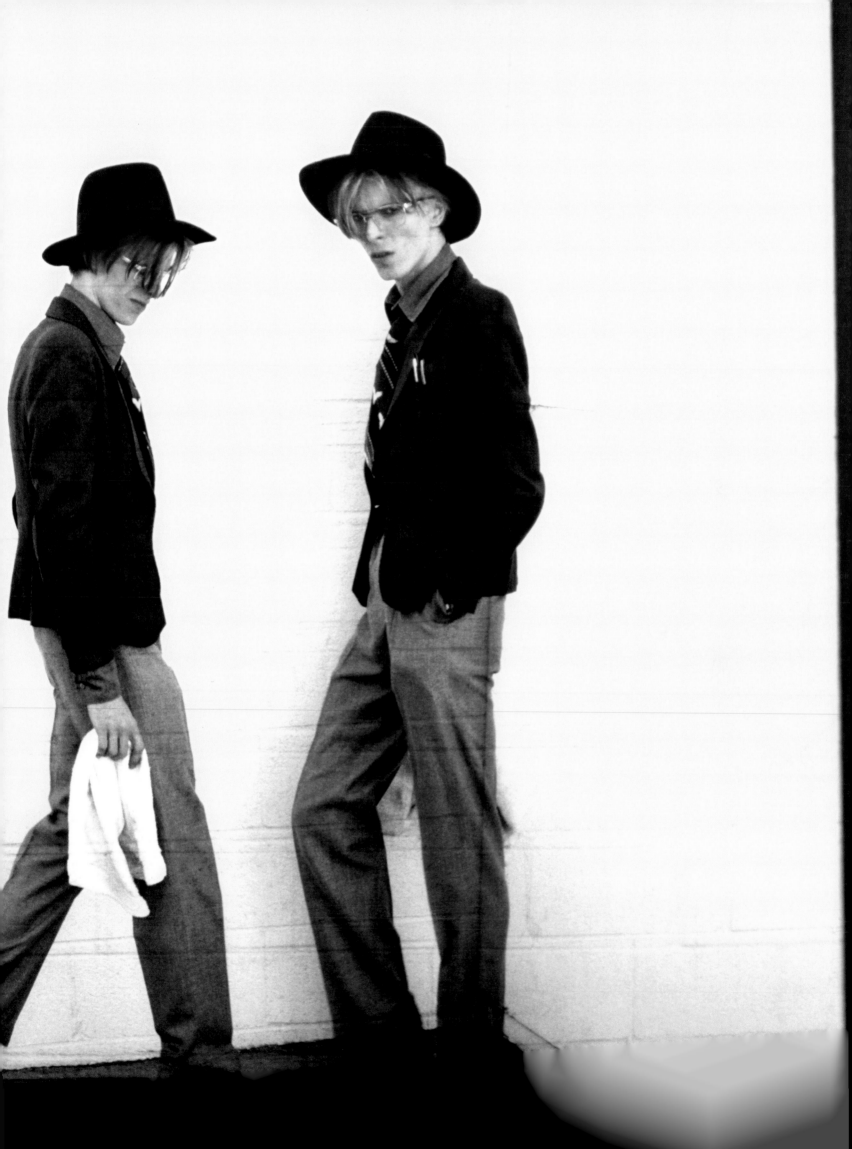

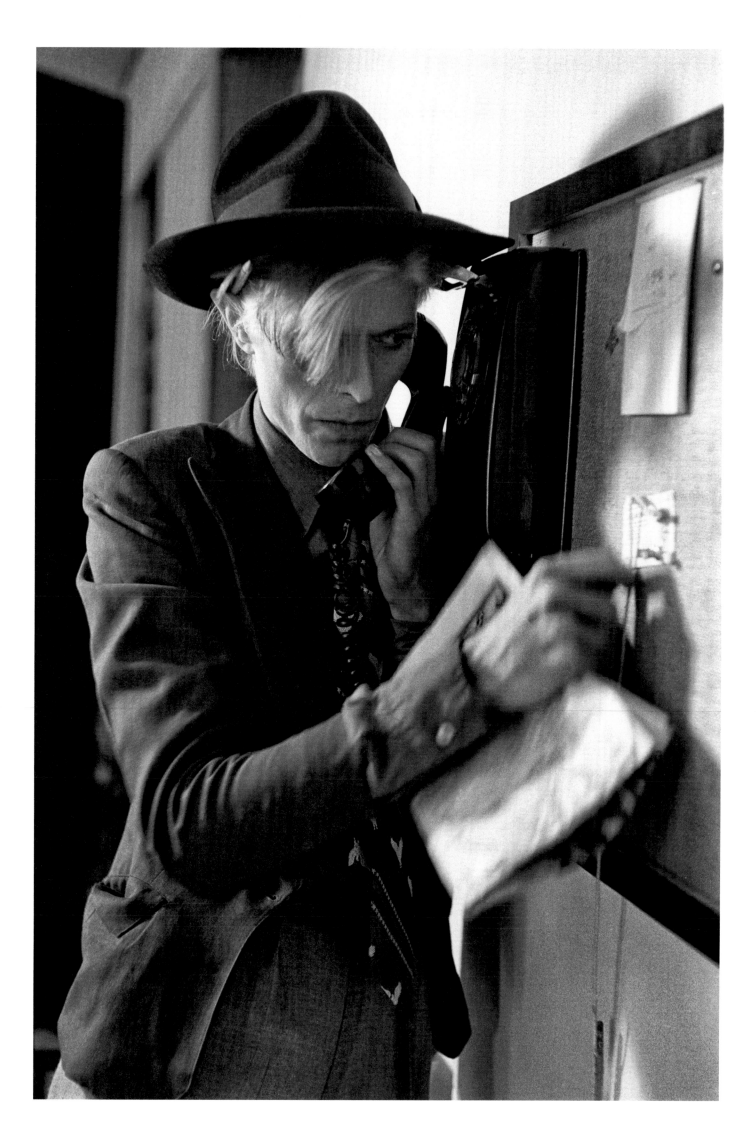

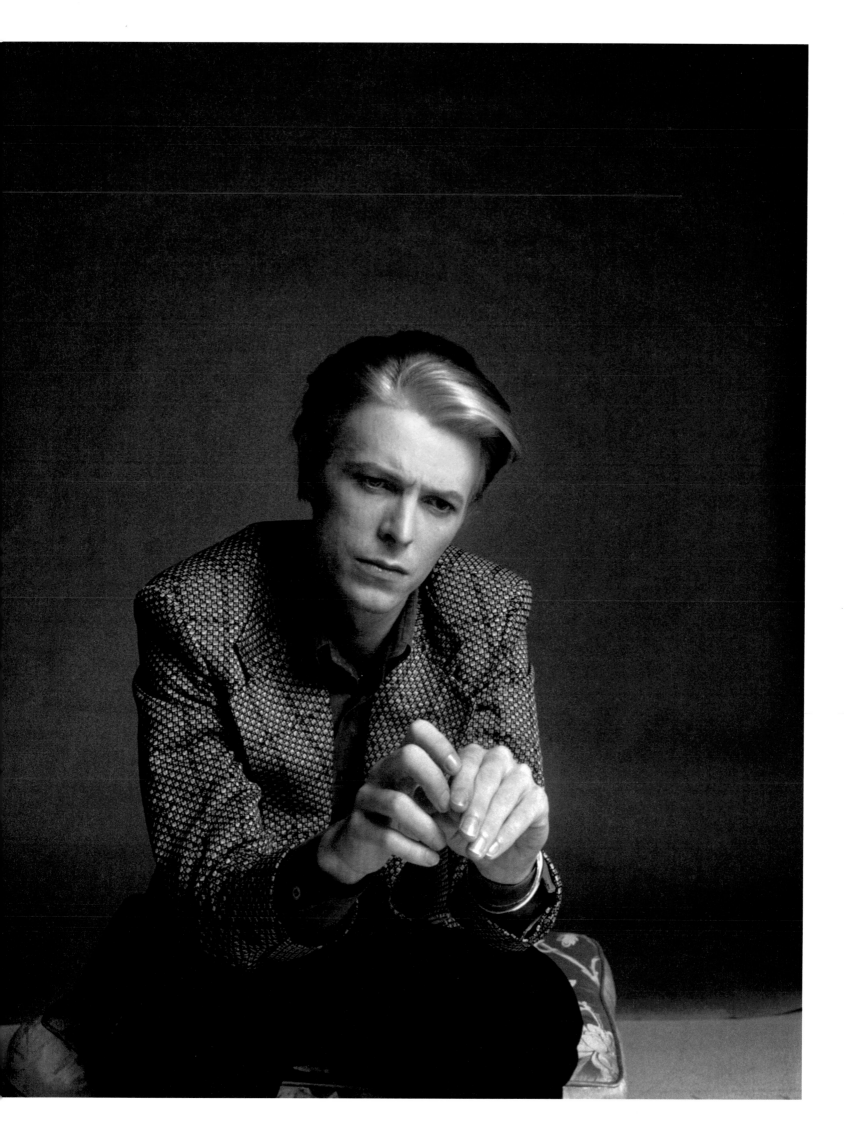

Afterword:
Michael Lippman

Meeting David Bowie changed our lives. He taught me so much about
live performance, an artist's image, photography, and songwriting.
Working with him was an incredible experience, and he introduced me to
John Lennon.

Nancy and I first saw David in the early 70s when we were having
dinner at the Rainbow Bar and Grill on Sunset Boulevard. Sitting a few
booths away was a man with a white face and orange spiky hair. He
was wearing a green lamé suit and he was sitting with our friend, Miss
Christine (Christine Frka), a member of the girl group the GTOs. Later that
night, Miss Christine brought
David up to our house on
Kings Road and that was the
beginning of our beautiful
adventures with David.

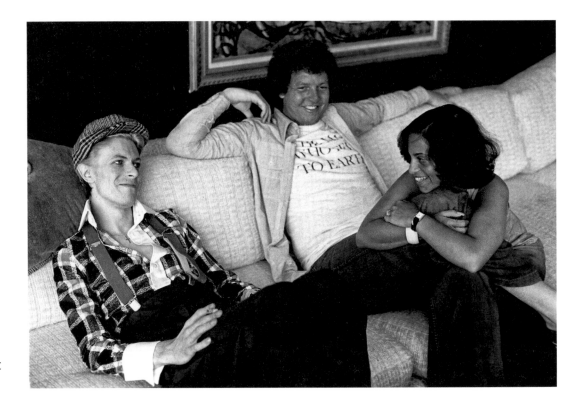

I had been hearing
wonderful things about the
photographer Steve Schapiro
then, and I brought David
in to do the initial photo
session with him. As it turns
out David, Steve, and I went
on to work together on a
variety of projects including
the *Cher* show and *The Man
Who Fell to Earth*. I've always
loved having a great working
relationship with someone
and having it turn into a great
friendship. Nancy, our sons,
and I have continued our
close friendship with Steve,
his wife Maura, and their son, Smith.

I've always been a motorcycle enthusiast and some of my best times
were on my bike riding through the hills of Hollywood. During this first
photo shoot with Steve, I was more than happy to see that one of the props
was a motorcycle! David was happy to dress as his version of a biker.

During this shoot David decided the shirt he was wearing wasn't what
he wanted, and so he borrowed a shirt from one of the assistants. He then
asked me to find him some paint and he painted the diagonal stripes on

the shirt and pants himself. That outfit had such an impact on him that 40 years later he duplicated the outfit for "Lazarus," the last video he would make before his death. Wow, he had come full circle.

One of the wonderful things that David did for us was to introduce us to Geoffrey MacCormack, also known as Warren Peace, a vocalist, composer, and dancer. He and Geoff had been childhood friends since their schooldays in Bromley, and remained best friends until David's death. Geoff has been our close friend for 45 years, and we adore him.

The photograph here in this book with David, Nancy, and me was taken when David was renting Marilyn Monroe's house on Doheny Drive. Steve was there shooting David, and he caught this moment with the three of us. David was always very fond of Nancy and would often borrow her yellow VW convertible and have Geoff drive him around Hollywood.

I'm enormously proud of the work that David and I did together. Some of the most memorable moments: first white artist to perform on *Soul Train*; his song "Fame," (co-written with John Lennon), reaching #1 on *Billboard's* Hot 100, his biggest hit at that point in the U.S. When I read the script of *The Man Who Fell to Earth*, I knew he was the only person who could play that part. When David appeared on the *Cher* show, he did something that no one else had ever done before: a six-minute medley. David was a true genius, an innovator, and a fascinating person to be with.

Afterword:
Steve Schapiro

I photographed David Bowie for the first time in 1974, when his manager Michael Lippman asked if I had the time to work with his client. I said yes before he could finish his sentence. 1974 was a great year for Bowie, and I was excited.

Throughout my 50-year career I have photographed some really incredible people: Andy Warhol, Muhammad Ali, Bobby Kennedy, Martin Luther King, Jr., Marlon Brando, Barbra Streisand, Frank Sinatra...and each time it's different, sometimes tricky, sometimes not so stressful. You never know what to expect. Usually, I'm very nervous when I'm about to photograph someone for the first time. When I work, I try to be very quiet so that my subject's personality takes center stage. With Bowie, I knew instantly that the shoot would be easy.

I booked a studio in L.A. for a Saturday. My assistants and I arrived at 9 AM to prepare and set up lights. At four o'clock David Bowie appeared. From the moment he arrived—such flaming red hair!—we seemed to hit it off. If you were expecting a wild rock-and-roller with cases of beer and a screaming entourage, you'd have been severely disappointed. David was soft spoken, calm, and extremely polite. He was filled with ideas about the shoot. When he heard that I had photographed Buster Keaton, one of Bowie's heroes, we definitely became friends.

David disappeared into the dressing room. We put up a roll of grey background paper. Being familiar with "Ziggy Stardust" and his other fanciful characters, my assistants began speculating on how he might be dressed when he came out.

It took awhile for his entrance, and to our surprise David appeared in a simple navy cropped shirt and pants, but with diagonal white stripes freshly painted on them, which he had done himself. Peaking out of his black sandals, each of his toes had been painted white as well.

In his hand he held a roll of purple wallpaper which he proceeded to slowly unroll near to the background paper. I was determined to photograph everything that I saw. My strobe lights went off constantly. Then, Bowie picked up a black marker and started to draw large and small circles on the background and soon there were other lines that swooped up and down along the paper, even a question mark.

Beyond a doubt he was immersed in his own world and everything seemed to have some secret meaning. On the paper taped to the floor he began to draw a complex series of interconnected circles, which I only learned later was a diagram from Kabbalah [In Schapiro's photographs Bowie can be seen drawing lines through the Sephirot he created for the

shoot; the Sephirot are the ten emanations and attributes of God which sustains the universe.—Ed]. It was all a different side of David Bowie than I had expected to see.

As the day and early evening progressed, we would change the colors of our backgrounds and he would come out dressed differently, but never in the sexual and suggestive outfits I had expected. It seemed with each new change of clothes a new character appeared, each with its own story. I'd pick up my camera ready to shoot, and he would abruptly withdraw, explaining he'd forgotten something, rushing back to the dressing room. Twenty minutes later he'd appear in a brand new outfit. It was more than frustrating, not being able to shoot some amazing looks, but fortunately there were a lot of changes, and a lot of great ones were caught. At one point later in the session we wanted to do a series of close headshots for magazines articles. We decided together that green was the worst possible color for a magazine cover; we laughed, and had a blast shooting with one. Eventually in 1976 it did become a cover for *People* magazine! One of his favorite outfits for the day was a jacket and a black hat which accentuated his red hair. We brought a large studio mirror outside and placed it near a white brick wall. David sat on the ground and started writing on it. That became an album cover in November 2014 for the "Nothing Has Changed" series.

As time progressed, I took the last photo at 4 AM in the morning of Bowie on his bike. I lit it with the headlights of a car.

That day it seemed Bowie was trying out all kinds of characters, costumes, and ideas to see which would work best for future projects. I'm certain he was already well into his thinking about *The Man Who Fell to Earth*. He called me later to work on that project as well, which resulted for me in album covers for *Station to Station* and *Low*. I got calls in November 1975 from Bowie to photograph him on the *Cher* show. I had trouble finding much chemistry between the two of them.

For his 1976 tour he asked me to work with him on the tour program book and sure enough he wanted my photo of Buster Keaton to be included.

There were other calls at other times. In 1986 my family and I were walking out the door to have our first real three-month vacation in France when David rang us up and asked if I could do a tour. It was hard to decline. Working with genius is exhilarating. Working with Bowie was unforgettable.